Julian Heynen James Lingwood Angela Vettese

Thomas Schütte

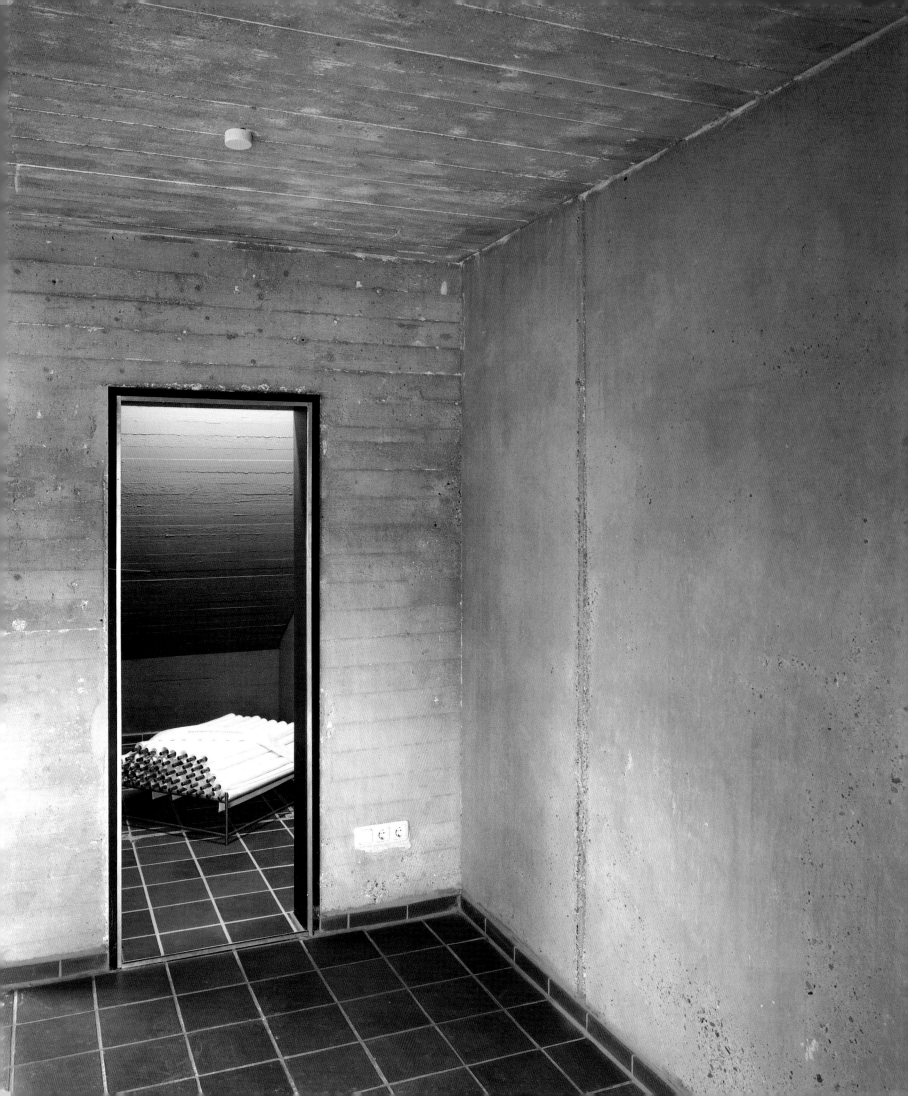

Publisher's Acknowledgements
Special thanks are due to **James Lingwood**, London. We would also like to thank the following for their kind permission to reproduce images: **Richard Deacon**, London; **Juan Muñoz**, Madrid; **Claes Oldenburg**, New York; **Niele Toroni**, Paris. Thanks to **James Peto**, London, and **Clare Manchester**, London.
Photographers: **John Abbott, Roland Aellig, Peter Cox, Kristien Daem, Peter Dipke, Elger Esser, Volker Döhne, Jacques Faujour, Dorothee Fischer, Michael Goodman, Jost Hiller, Candida Höfer, Axel Hütte, Christin Loster, Ernst May, Wolfgang Maxwitat, Helge Mundt, Philip Nelson, Tom Powel, Rothweiler, Enzo Ricci, Thomas Ruff, Tomasz Samek, Paolo Mussat Sartor, Thomas Schütte, Dieter Schwerdtle, Stalsworth/Blanc, Andrea Stappert, Thomas Struth, Dimitris Tambiskos, Nic Tenwiggenhorn, Elke Walford** and **Stephen White**

Artist's Acknowledgements
I want to thank the following people for their help in putting this book together:
The Curators: James Lingwood; Catherine Lampert; James Peto; The Editors: Iwona Blazwick; Gilda Williams; Clare Stent; The Writers: Julian Heynen; Angela Vettese; The Designer: Stuart Smith; The Home Base: Christine Ott; Ingrid Kurz; The Photographers: Nic Tenwiggenhorn; Peter Cox; John Abbott and others.

All works illustrated are in private collections unless otherwise stated.

Phaidon Press Limited
Regent's Wharf
All Saints Street
London N1 9PA

First published 1998
© Phaidon Press Limited 1998
All works of Thomas Schütte are
© Thomas Schütte.

ISBN 0 7148 3714 8

cover, **United Enemies, A Play in Ten Scenes** (detail)
1993
10 offset lithographs
69 × 99 cm each

page 4, **Haus des Gedenkens** (House of remembrance) (detail)
1995
Neuengamme Labour Camp

page 6, **Kirschensäule** (Cherry Column) in progress,
1987

page 38, **Ringe** (Rings) (detail)
1977
Wood, paint
Dimensions variable, ø 12 cm each ring

page 118, **Kirschensäule** (Cherry Column) in progress,
1987

page 128, **Das Bad** (The Bath)
1984
Three painted wooden structures, *from background to foreground,* ø 120 × 100 cm; ø 250 × 65 cm; ø 160 × 80 cm; Banner with spraypaint, 200 × 215 cm
Collection, FRAC Rhône-Alpes

page 144, **Große Geister** (Big spirits) in progress,
1996
Plaster
h. approx. 300 cm

This edition coincides with the exhibition **Thomas Schütte,** curated by James Lingwood.

Whitechapel Art Gallery, London
16 January - 15 March 1998

De Pont foundation for contemporary art, Tilburg
28 March - 21 June 1998

Fundação de Serralves, Porto
9 July - 6 September 1998

Catherine Lampert, Director, and James Peto, Exhibitions Curator, Whitechapel Art Gallery; Hendrik Driessen, Director, De Pont foundation for contemporary art, Vicente Todoli, Director of the Museum, Fundação de Serralves, wish to thank the artist and the following who generously lent work to the exhibition:

Public collections:
FRAC Picardie, Amiens
De Pont foundation, Tilburg
Kunstmuseum Wolfsburg
Moderna Galerija, Ljubljana
Carré d'Art, Musée d'Art Contemporain, Nîmes
Musée national d'art moderne, Centre Georges Pompidou, Paris
Museo Cantonale d'Arte, Lugano (Donazione Panza di Biumo)
Museum voor Hedendaagse Kunst, Ghent
Stedelijk Van Abbemuseum, Eindhoven
Tate Gallery, London
Private collections:
BACOB Collection, Brussels
Borja Coca, Madrid
Galerie Konrad Fischer, Düsseldorf
Collection Martine and Didier Guichard, Saint-Etienne
Collection Herbert, Ghent
P. and M. Iserbyt, Brussels
Guido van Middelem and Greta Dupont, Ostend
The Saatchi Collection, London
Joachim Tiffert, Düsseldorf
O. M. Ungers, Cologne
as well as those private collectors who wish to remain anonymous.

The exhibition at the Whitechapel Art Gallery is supported by the Henry Moore Foundation and presented in association with the Goethe-Institut, London.

The curator and organizers of the exhibition would like to thank the following for their assistance: Bart Cassiman, Ghent; Dorothee Fischer and Gundula Schulze, Galerie Konrad Fischer, Düsseldorf; Marian Goodman Gallery, New York; Martin Kreyssig, Hamburg; Galerie Philip Nelson, Paris; Jacqui Todd and Jürgen Voerath, Produzentengalerie, Hamburg.

Contents

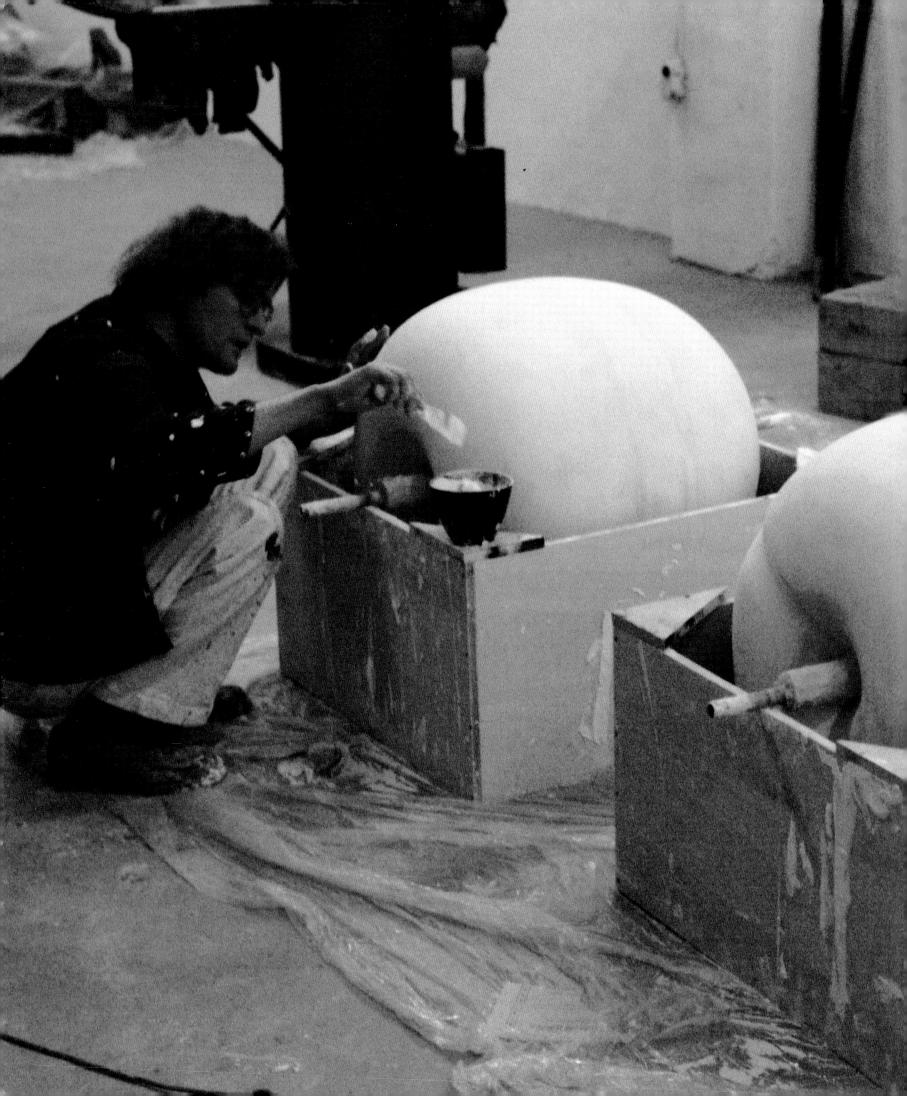

Contents

Haus des Gedenkens (House of remembrance)
1995
Neuengamme Labour Camp

Introductory Note
The day before James Lingwood interviewed Thomas Schütte in Düsseldorf, he had
travelled to Neuengamme, a labour camp established by the Nazis in 1938 outside
of Hamburg. Until the liberation of the camp at the end of World War II, over
100,000 people, mainly Russian, Polish, Dutch, French and German, had died in
the camp. In 1995, Schütte had been asked to make a small room of remembrance
within a modern documentation centre on the site of the labour camp. They agreed
to begin the interview by considering this project.

James Lingwood What was your brief in working at the Neuengamme labour
camp?

Thomas Schütte **The context was the fiftieth anniversary of the liberation of
the camps in May 1945, which also marked the German surrender and the
end of World War II. People who had done nothing for the past fifty years
suddenly decided to do something.**

**I was invited in early 1995 to do a work for a small room of remembrance.
But the proposed space was just a low-ceilinged little office room inside a
'documentation centre', and this made me very angry. I recognized
immediately how complicated the situation was, and the lack of will on the
part of the people involved and the lack of a political concept.**

**So in one meeting I improvised a plan for the entire building to make a
decent event for that one day of the anniversary, without my doing any
sculpture.**

Lingwood What was there before?

Schütte **A very shabby installation of left-overs, didactic photos and panels, a
bureaucratic way of trying to touch people, lots of text and some barbed
wire. It was such a muddle that it became a duty for me to be involved.**

Lingwood Did you remove a lot of visual material?

Schütte **Almost everything, all the vitrines, partitions, the entire lighting
system, the sound system, everything except a very large model of the site
made in the 1940s. The documentation centre moved to a new site down the
road for the occasion of the anniversary. The main idea was to get a decent
space by kicking everything unnecessary out – even sandblasting the plaster
and paint off the walls and returning to some kind of shell which could
breathe again. At the end, most of the walls were painted blood red and a
new model of the whole site was commissioned and placed opposite the old
one.**

**Because time was short – only about three months – the city had to
agree, without getting into long, fruitless discussions over power and money.
I told them I could work as a kind of advisor or director, but not as an artist. It
wasn't about works of mine being fabricated or presented. I more or less just
developed the concepts and tried to convince others to help create a strong
experience of the place. Not in a normal way by bringing things in, but by
stepping back and rebuilding very carefully using only the models and the
record books and the names.**

So my job was somehow a service – a public service.

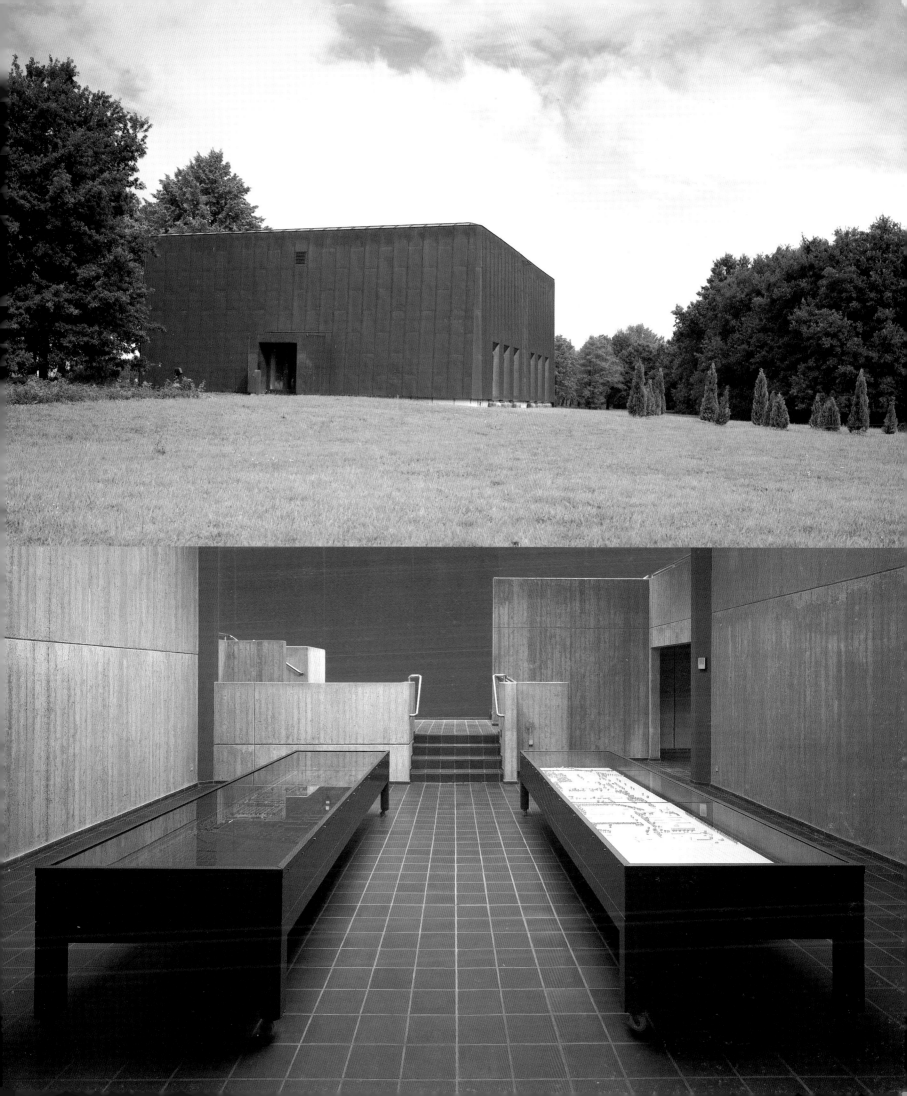

Lingwood They agreed not to have something monumental?

Haus des Gedenkens
(House of remembrance)
1995
Neuengamme Labour Camp

Schütte **Yes. At the same time in Berlin there was a big discussion about a proposal for a national monument to the victims of the Nazis. More than 500 artists and architects participated in the competition, mainly designing minimalistic structures and speaking with heavy forms and heavy materials about heavy human problems. The competition was cancelled; just now the whole issue has been resurrected – it's a very problematic situation once more.**

Lingwood Which memorials do you think are most effective in terms of confronting people with their historical responsibility or awakening a memory in a sort of unmanipulative way?

Schütte **The Vietnam Memorial in Washington I found very, very fascinating because it's so discreet and not imperialistic at all. In the case of the Neuengamme project, the architect of the building from the 1980s was very happy to be involved again and to return the building to a clear structure. It has a strong echo and inside you are very much aware of yourself. He had worked a lot with sacred architecture and paid particular attention to the acoustics, the ears of the visitors.**

Lingwood Was it important to include the individual names?

Schütte **The names were the only remains of thousands of people, and many died even without their names being recorded. Actually, the banners were by Arne Petersen – it was a project that was planned before I had been invited. It was not an issue for me to include them within my overall concept. The situation was very, very complicated, with the prisons around and the old factories and so on, but I think we were all fortunate to achieve this in such a short time. I hope the city will take good care of it and keep it open to the public.**

 When the day of the anniversary came, the focus of the discussion in this country was that it wasn't only the concentration camps which were freed by the allied troops: the Germans were liberated, too. So in their hearts the Germans were not responsible for those twelve years, they were the victims too. It was a big relief when the anniversary passed, with its cynical misunderstandings and bad conscience.

Totenbücher (Death record books) from **Haus des Gedenkens** (House of remembrance) 1995 Neuengamme Labour Camp

Lingwood How does your sculpture *Die Fremden* (The Strangers, 1992) relate to this problem of a sculptural means of remembering? And what kind of historical situation did that come out of?

Schütte **At a certain moment in Germany, after the unification in 1989 when housing problems and unemployment became more severe, the foreigners – the ones who had come from the East or from Yugoslavia or Africa – became the scapegoats. They were held responsible for everything. A number of refugee hostels were burnt down, and the State did nothing. And by letting it continue, the State actually promoted it. Still today a lot of foreigners' houses or hostels are set on fire; racist prejudices do not just go away.**

Lingwood You made the work specifically for the 1992 Documenta; was that

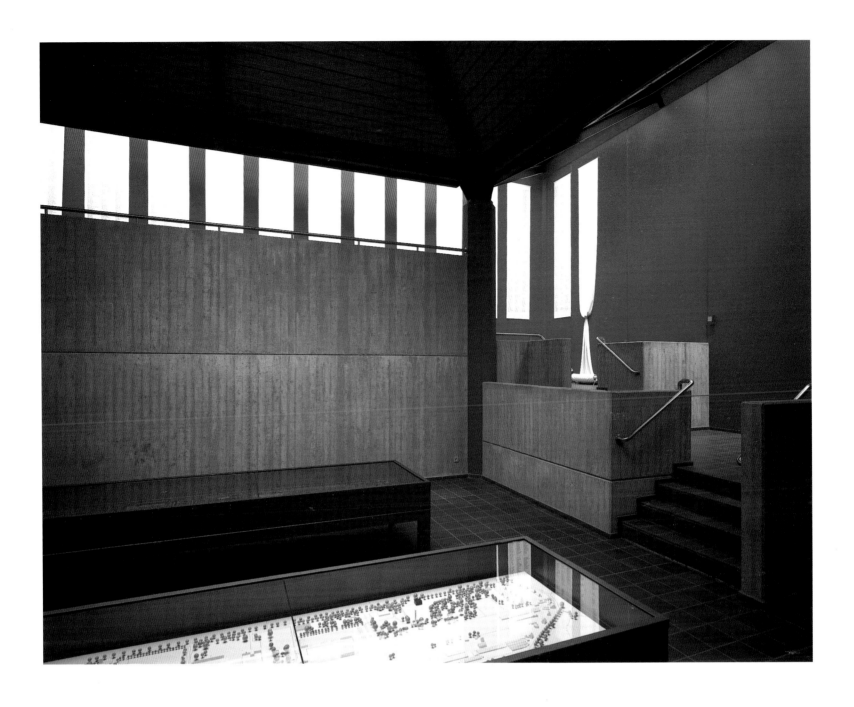

a public stage which you wanted to use to engage with a particular political moment?

Schütte **It was actually a public commission from the department store in Kassel next to the Fridericianum. It is a very old *palais*, partly rebuilt in the 1950s and now a big, modern, clothes store. It was being renovated then.**

Lingwood They wanted figurative sculpture?

Schütte **No, they wanted something like the 'cherry column' which I had done in Münster, placed on the street in front of the building. They wanted sculpture as a logo or a traffic sign, but I immediately had this idea of putting figures on the roof.**

Lingwood Figures of foreigners?

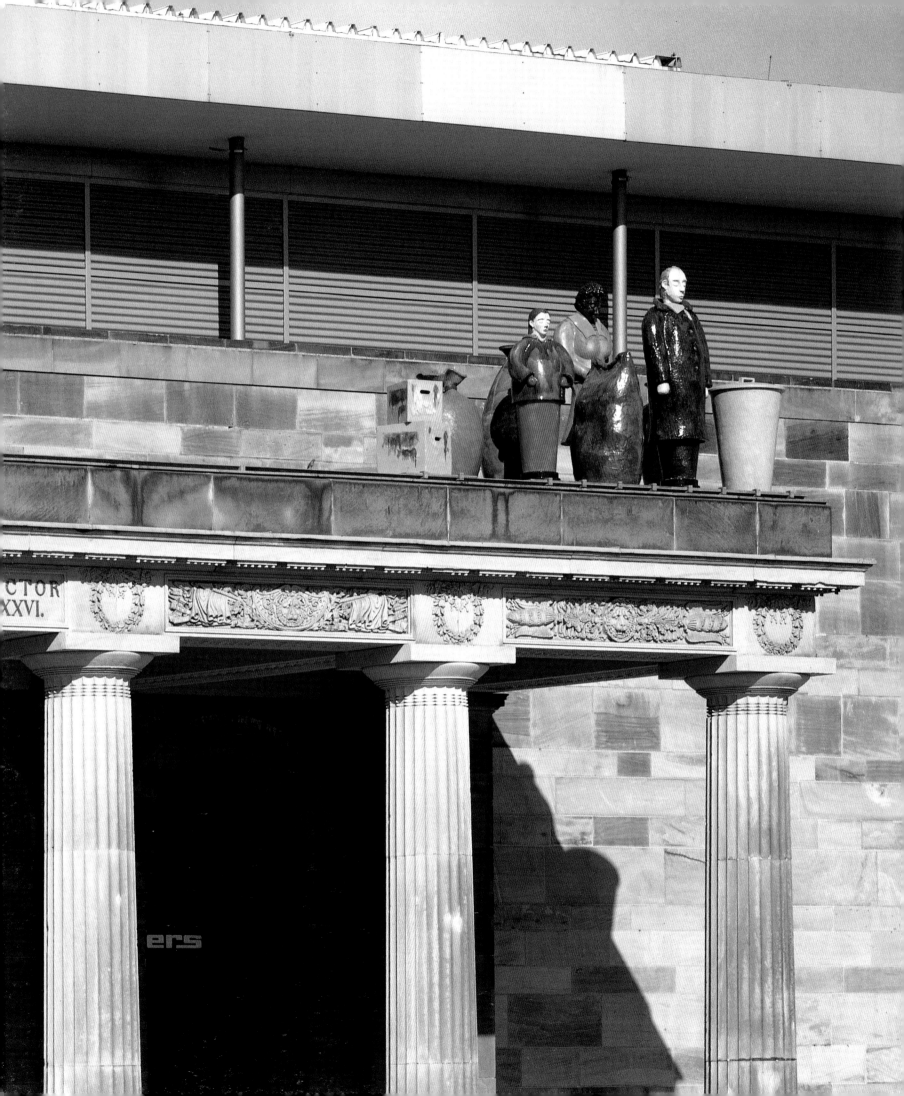

Die Fremden (The Strangers)
1992
Glazed ceramic
Lifesize
Installation, Documenta IX,
Kassel, 1992

Schütte No. The first idea was just of figures with luggage; the title came later. I knew the context well, particularly from my visit to Documenta 5 in 1972, and still remember that performance by James Lee Byars, standing in a blue suit among the muses on the roof of the Fridericianum, holding a megaphone and shouting names to the crowd on the square. These allegorical figures on top of the building had stayed in my mind.

Lingwood At what point did it change from a project about placing figures on a roof into something with an explicitly political dimension?

Schütte This was not clear; we had more technical considerations than political ones. For me it was first of all a very interesting site overlooking this place, and I immediately had this image in mind of placing some colourful, static figures on top of the building as a permanent installation. The only way to get bright colour is to use either plastic or ceramic, and with ceramic the colour is better.

Basically, in 1992 the political dimension was changing every week – and all these issues are still unresolved. What defines a German, the passport, the blood, the country of birth, the language or the mentality? The parliament even changed the constitution, but it did not help much.

Lingwood I'm still keen to know at what point the figures become refugees?

Schütte After its installation the piece was reproduced a lot in the press, and there it was given its definitive title, its political dimension, in the sense of the way in which it was read. For many people, *Die Fremden* worked as an excuse, a kind of relief in a terrible situation.

Lingwood Were they related to Oskar Schlemmer's figurative forms?

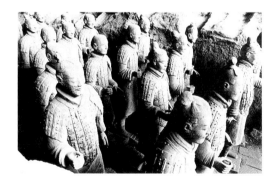

Figures from the Mausoleum of
Qin Shihuangdi
c. 220–210 BC
Terracotta
Dimensions variable
Collection, Shaanxi Provincial
Museum

Schütte No, I wasn't thinking about Schlemmer, but certainly I was impressed by the Chinese terracotta figures which are so amazing on a technical level. My figures are built up in clay and fired in one piece, so they cannot have a steel armature inside them. Basically they were geometric vases up to the hip, and then the upper part of the body was worked in a more abstract way. The face is quite realistic but then the hair is more expressionistic. So there was this idea of a synthesis of different figurative styles blending into something new.

Lingwood Why are the eyes closed?

Schütte Limitations of time and technique. I did not want them to be blind, I just wanted something simple and convincing. The question was, are they arriving or departing, are they bringing something or taking something, and why are they here at all? What culture or attitudes or ideas do they carry with them? There is always the feeling that people who come from elsewhere are taking things away; that they are thieves. The eyes are cast down so that the figures have this shameful expression. This solved a lot of problems and gave us more time to work on a richer variety of bodies and of luggage. I think the luggage defines them as strangers.

At the end of the exhibition, I divided the whole work into three families,

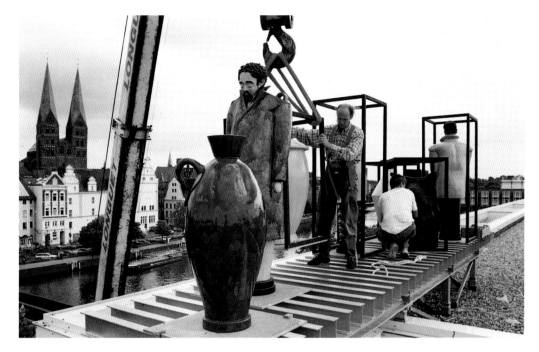

Die Fremden (The Strangers)
1992
Glazed ceramic
Lifesize
Installation, Lübeck, 1995

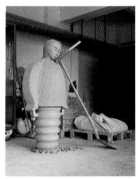 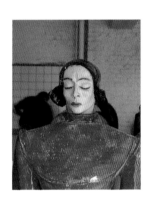

each with one man, one woman, one child and some luggage. One part stayed in Kassel, hopefully for ever.

Lingwood Do you like the idea that some of the families are still on the move?

Schütte **It is like real life, some stay, some go, some keep moving. One family found quite a good place in Lübeck, on the roof of an oversized conference centre. Lübeck is one of the places at the centre of this racist problem, a beautiful German humanist city where the houses are still being torched.**

Lingwood The sculptures have to be in a public situation?

Schütte **Yes, they have to be exhibited as a group, they have to be outside, and they have to be in a place where they catch the sunlight, otherwise the ceramic makes no sense. The public shouldn't get too close to them, no closer than ten metres.**

Lingwood Did the figurative tradition become devalued because of the way the figure had become used in totalitarian statuary?

Schütte **In my eyes the figurative tradition failed at the point when the artist had to create heroes in a democratic system, which nowadays is something television networks can do much more effectively.**
The power is no longer represented by a king or a single figure, it operates through a system or many, many different, overlapping nets which tend not to be visible and to hide away. So the power structure is basically anonymous and it's impossible to give it a face or even a body. My figures in Kassel are victims, basically lifesize vases, precious containers with modest faces. I hope everybody feels that the figures have an interior.

Lingwood You mentioned the importance of being useful. Do you see that use primarily in terms of creating symbols, images or experiences which raise

consciousness about such issues, or do you also mean in a more directly functional way? Your architectural models play with this dilemma, with the promise of a public role.

Schütte **As an artist you have these ego problems, and feeling useful fills the hole. If I have a commission or a show, I always ask myself, what could be necessary? I don't ask myself what I want to do; I ask myself, what really is the problem? What could be necessary, what could be useful, what is missing?**

Lingwood It's unusual for an artist to have this idealism …

Schütte **I am not an idealist. I would be happy if I was, but I am not. I'm strictly a pragmatist.**

Lingwood At what point did you lose your idealism?

Schütte **I never had it.**

Lingwood Not even at the art academy?

Schütte **No. I was always busy and enthusiastic, but never idealistic. I never read any idealistic philosophy. The only thing I read was Nietzsche when I was about eighteen, and most of the anarchist writers, but after that it was impossible for me to follow big theoretical constructions or all-embracing ideological views of the world.**

Lingwood What did you get from Nietzsche?

Schütte **Doubts …**

Die Fremden (The Strangers),
in progress
1992
Niels Dietrich workshop, Cologne

Große Mauer (Great wall)
1977
10 × 20 cm each 'brick'
Oil on wood
Installation, Düsseldorf Academy

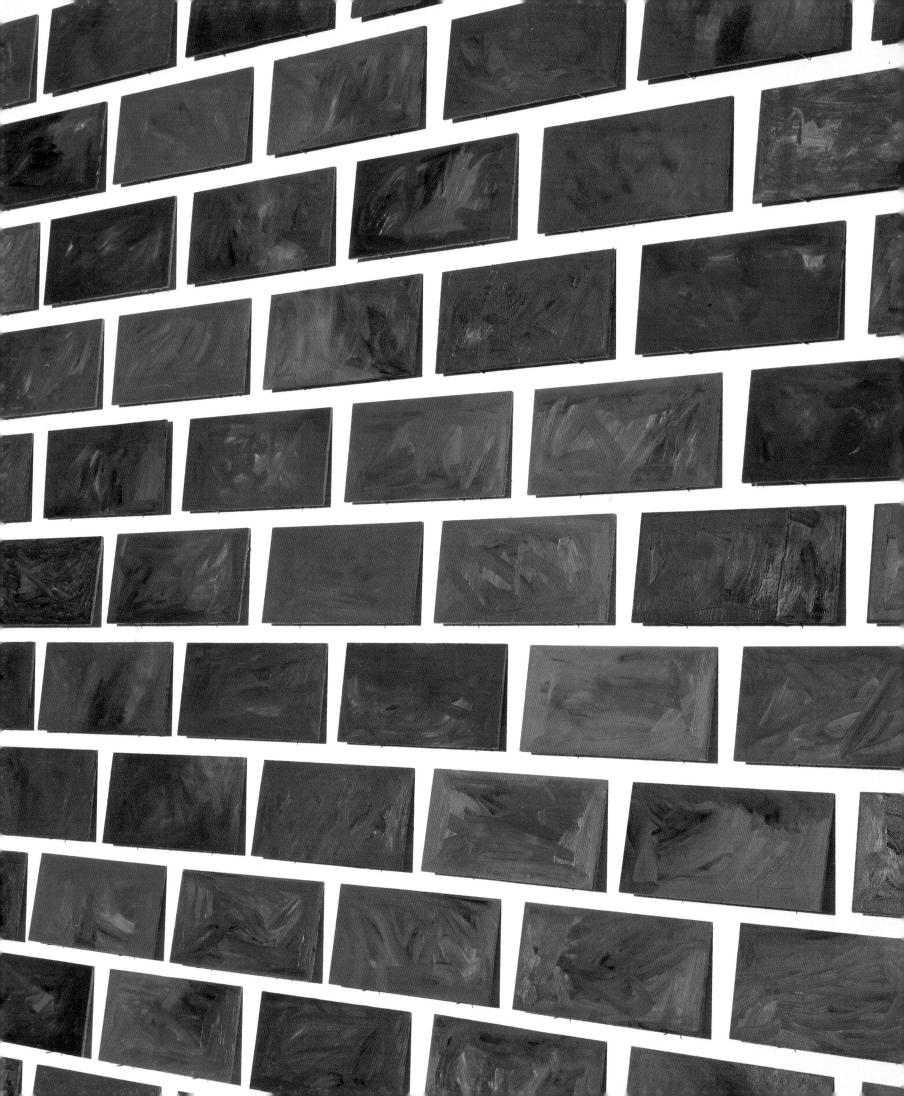

Niele Toroni
Marks made with a no. 50 brush,
repeated at 30 cm regular intervals
1975
Lacquer on laminated paper
490 × 140 cm

Lingwood There was a strong sense of social responsibility when you were a student at the Düsseldorf Academy. How did you relate to an older generation with their utopian models or ideas?

Schütte **Basically we all grew up together in the 1970s and it was more or less a period of research for everyone. It wasn't like the big consumption period of the 1980s – the funfair. There wasn't a powerful market, and actually there weren't any big media heroes except Warhol. Everyone was very approachable. Perhaps an idea of responsibility comes from that situation; there was space for a lot of different attitudes, even for the terrorists. Documenta V was very important – a very influential experience for me even today.**

Lingwood What particularly impressed you there ?

Schütte **A sense of incredible freedom, with ideas and materials.**

Lingwood How strong was the aura of Beuys for you ? He was more concerned with an idea of direct action.

Schütte **I didn't speak with him, but he was a fantastic showman. His discussion basically revolved around his mythology and social ideas. He was pretty much hated at the Academy, especially by the conceptual and minimal artists.**

Lingwood So after Documenta in 1972, you decided you wanted to go to the Düsseldorf Academy?

Schütte **In 1973, I sent my drawings there and they accepted me. It was just fantastic because there was so much energy. Carl Andre, Bruce Nauman, Sol LeWitt, On Kawara, Richard Serra showed at the galleries like Konrad Fischer and Schmela, as did the professors, Gerhard Richter, Bernd and Hilla Becher, Klaus Rinke. All these people were in the Academy or in the bar or in the city. It wasn't about studying but just being a part of it, breathing it in all the time, inside the academy but also outside. Beuys was kicked out by the State shortly before, but he still had a strong presence in the city.**

Lingwood So what was the real motivation for you and your fellow students?

Schütte **To keep up with ideas, to keep on pushing the research. To be a colleague rather than a student. And to try and work out your own position amongst all this discussion, and to learn the grammar and the semantics. And certain tricks. Benjamin Buchloh was teaching for a short time and his position was discussed a lot.**

Lingwood Your decision as to the work you could make seems to have derived from certain conceptual models. In 1975 you couldn't have considered making a figurative sculpture, for example.

Schütte **That's right.**

Lingwood What were you doing at the Academy?

> Schütte **At the beginning I was painting after photographs. I stopped and
> then for a couple of years I was interested in working with decoration, like
> Daniel Buren and Niele Toroni.**

Lingwood Did that mean decoration as a kind of deconstruction of classical
pictorial space or as a way of looking at ideas of beauty or utility? Was the idea
of beauty of any interest?

> Schütte **Nobody was talking about deconstruction at the time. The key
> questions were an awareness of context and the framework of the museum.
> The idea of the fake and artifice was interesting to me, the idea of playing a
> role. Mimic and mimicry, or even camouflage.**

Lingwood So what were you mimicking?

> Schütte **The idea of being positive. I made a lot of decorative work, works
> that you could live with. I made several installations in private homes – not
> to shock people, but to express an idea of permanence and an ambition for a
> better life. Beauty was a subject, too. But I think more ironically than the
> older generation do: they really could believe in themselves.**

Lingwood Yesterday I saw your early work *Lager* (Storage, 1978) reinstalled
in the Hamburger Kunsthalle. It seemed to suggest that there were all these
possibilities that might once have been available to a painter but which couldn't
be used any more. It seemed quite melancholic to me, a colour-chart waiting to
be formed but not being formed.

> Schütte **I found it very optimistic at that time. Somehow the idea came from
> the Russian productivist movement after Constructivism, when artists
> worked with real life objects for mass production, like in the Bauhaus.
> In *Lager*, there were fifty sets of three varnished boards of wood with
> holes in them for hanging. It could be shown or extended in many different
> states. It was a colour-chart in the form of storage, with unlimited
> possibilities of use.**

Schiff (Ship)
1980
Cardboard
25 × 50 × 30 cm

(König Postcard Shop, Cologne),
with wall painting by Ludger
Gerdes
1981
Ceiling painting
5 × 8 m

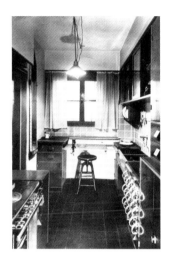

Grete Schütte-Lihotzky
Frankfurt Kitchen
1926

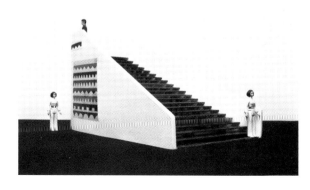

Lingwood So the work was in a state of waiting to be, of not being fully made,
like the models are in a state of waiting.

**Schütte It was better to keep things in the air rather than close them down,
and storage is a more potential state. The models came from a similar way of
thinking – if I could afford a better studio, what might it possibly look like?
The if-questions are always essential.**

Lingwood You wanted to keep a series of options open?

**Schütte Options are what everyone has on computers, but I don't think they
are the same as possibilities. It was important for me to keep a lot of possibili-
ties in play. 'Repertoire' was an important word for us at the time. We played
roles, imagining offers or commissions for a particular kind of applied art.
This happened a bit later on, but not at that time. Nobody wanted their house
painted or designed by us, except the postcard shop of the König brothers
which I designed and painted with Ludger Gerdes.
It is important to have a repertoire of tools and tricks and solutions for
the different and even contradictory jobs you do. It was playful and it was
totally serious at the same time.**

Lingwood Most of the modes in which you work are for your temporary use,
to be taken up and then put down again?

**Schütte Yes, because I get bored very easily and when things get to a certain
level of production, I lose interest. It's difficult for me to repeat one idea over
and over again. But on the other hand there are themes that recur over the
last fifteen years, like the models for buildings on tables.**

Lingwood Would you have been interested in being an architect?

**Schütte This architectural debate, the postmodern debate at the end of the
1970s, was really important, and clarified how unsatisfying modern dogmas
had become. It was very refreshing that there were suddenly many more
ways, citations, and games possible. Nowadays I'm very happy that I am not
an architect; postmodern architecture has become totally obsolete. Basically
I continued playing around and I found out along the way that it was not
possible to work in such an open way in the film industry or in architecture.
Art is still the only place where you can do work this way.**

Lingwood What about theatre? The idea of staging has seemed to concern you
since the 1970s?

**Schütte I was quite close friends with the set designer people in the
Academy and actually this model-building comes from them. I took their
scale of 1:20: it's a very unusual scale but one which works for me. But the
theatre itself is not very convincing for me, either on or behind the stage.**

Lingwood In some of your first maquettes for the exhibition 'Westkunst' in
Cologne, 1981, there were figurines. Where did they come from?

Schütte I used figures from *Star Wars*, because they had the right scale and they were flexible. I just had a man and a woman, nothing else.

Lingwood Did the large aluminium figures relate to similar kinds of toys? They look like blown-up sci-fi figures or melted-down monuments ...

Schütte No, the form mostly comes from dealing with technical problems, and from the material. For example the first figurative sculpture was *Mann im Matsch* (Man in mud, 1982-83). It was a little wax figure and it was always falling off its feet. I didn't want to put it on a plinth or a base, so I cast it in a plastic box up to its knees. It was a simple technical solution but it was also an effective image, a kind of miniature sculpture and a large-scale model at the same time – the man in mud, the embodiment of being stuck.

So far as meanings are concerned, I would rather talk with my hands and through forms and let these creatures live their own lives and tell their own stories. Avoiding certain fixed positions is important to me, avoiding being too classical or too predictable ... I always hope that in the end the work will be physically present. That the works lead to essential questions is important.

Lingwood Could you say what the essential questions are?

Schütte The things you cannot talk about – these are essential. Some answers can't be spoken. I believe that material, form and colour have their own language that cannot be translated. Direct experience is much more touching than media, photographs and so on. The body and soul thing, space and light ...

Lingwood Had you thought about Rodin's or Degas' sculptures of dancers?

Schütte I cannot draw these art historical connections by myself. For instance I've never forgotten the early Greek sculptures, the Kouros figures. I found them much more impressive than the famous classical Greek sculptures.

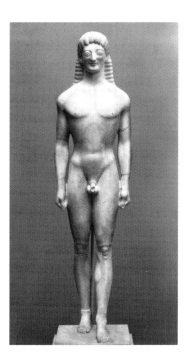

right, **Kouros from Tenea**
550 BC
Marble
h. 153 cm
Collection, Staatliche Antiken-
sammlungen, Munich

far right, **Mann im Matsch** (Man in mud)
1982-83
Wax, cardboard, steel
ø 150 cm

Lingwood These earlier, more archaic ones are totally statuesque.

Schütte **Yes, but they have a fantastic presence.**

Lingwood Even if you don't want to draw the connections yourself,
nonetheless you know that you are increasingly working within a figurative
tradition. The figures aren't models, or ciphers, or even actors now. You're
taking on the weight of a tradition which stretches back thousands of years.

Schütte **I don't feel the weight because when I do them, I'm not thinking about
the history, I'm thinking about the future. And in any case some traditional
forms are still very present, they are right here with us, and not just in books.**
**There are some ideas I'm working on at the moment – for instance to
have a whole figure, not distorted but contained within itself. Sometimes I
have the need to look at history, I am very interested in looking again at the
heavy figures of Maillol, or these brutal sculptures of Matisse, they are really
brutal, and there is a lot to learn from them.**

Lingwood Matisse's backs?

Schütte **The backs and the small figures and heads. If you made them today,
people would think they were completely eccentric. It's an interesting
challenge for me to handle these heavy subjects. Doing my work is like hiking
through the Alps and getting lost every ten minutes. It's important to have
different perspectives opening up all the time. I don't know where the path
leads to and there is nowhere to sit down. Sometimes there are companions
on the journey, which is very nice.**

Lingwood Are there other artists working with whom you have a dialogue –
with your colleagues from the Düsseldorf Academy ?

Schütte **In Düsseldorf, there are a lot of artists and there are many different
scenes and everybody's known each other for a long time and there's a con-
tinuing conversation, with Harald Klingelhöller, for example. But there's an
increasing tendency towards isolation. I do believe this, that forms and
colours and light constitute a language, and this is the conversation you have
in the studio, with material. I still think today that artists should have dirty
fingers. You don't have a real discussion in the museum any more, the
museum doesn't offer those conditions, it hasn't been a moral place for a long
time. But the studio can still be a moral place.**

Lingwood What about your relationship with other artists working with the
figure now, like Juan Muñoz for example?

Schütte **Muñoz was here last week actually, and I showed him everything in
the studio, and the casting workshop. Artists communicate with each other,
but through their works and not so much with their words. There is a
dialogue, and actually a real discussion going on, but it is through the works.
We learn from each other, from the things that work and the things that
don't. It's better to have this dialogue without the scaffolding of too much
theory or too much philosophy. That makes it too heavy, you can't stay afloat**

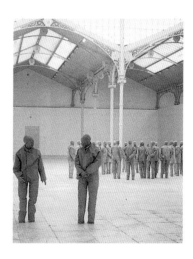

Them and Us IX , with Richard
Deacon
1995
Cast aluminium,stainless steel,
PVC, felt, animal hair
47 × 164 × 69 cm

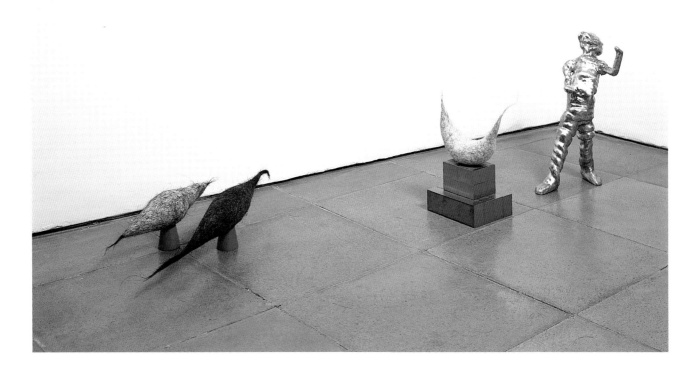

for long. But we talked a lot anyway, about the feet of the figures for example.

Lingwood All the figures before the aluminium ones seemed static, waiting or stuck in mud, or bound together. Even the aluminium ones seem frozen, like the victims of Mr Freeze in the last *Batman* movie.

Schütte For me they don't seem frozen. Unlike the ceramic figures, with this technique using wax, you can play with movement. In fact the starting point for all of the aluminium figures was a collaboration with Richard Deacon, which ended up as an exhibition called 'Them and Us' at the Lisson Gallery in London in 1995.

Lingwood There was a sense in which this exhibition was almost like a sequence of scenes from a tale by Swift.

Schütte Yes ... Richard and I had a fantastic discussion, perhaps no more than ten words in an hour. We developed our things separately, and we brought them together and then had a discussion about scale, monuments, man and animal, man and man, man and light, space and colour and so on ... all of these basic problems. We made twelve pieces – you could call them model situations. The gallery was our playground.

I like the small scale of the model because you have the whole world inside a room or on a table top. And then I can see some way forward. Or perhaps I can see that this is a dead-end, and I should turn around and go in the opposite direction. I still don't know what these figures are. I don't want to explain them, to cast them in words or philosophy, because very soon I am going to lose interest in them.

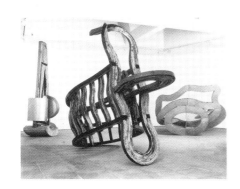

above, **Richard Deacon**
Installation, Lisson Gallery,
London
1987
l.to r., Troubled Water, 1987; Fish
Out of Water, 1987; Feast for the
Eye, 1986-87

opposite, **Juan Muñoz**
Plaza (Madrid)
1996
Resin, pigment
Dimensions variable

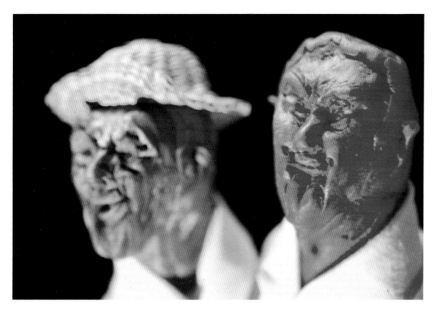

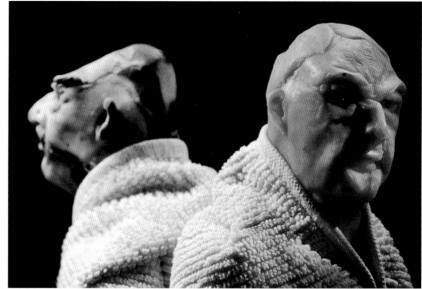

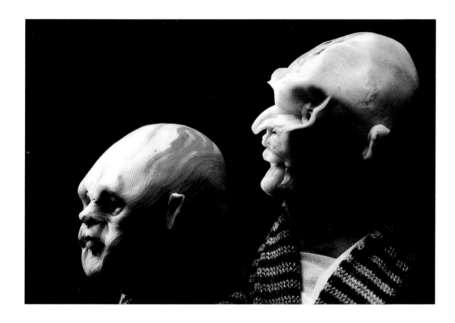

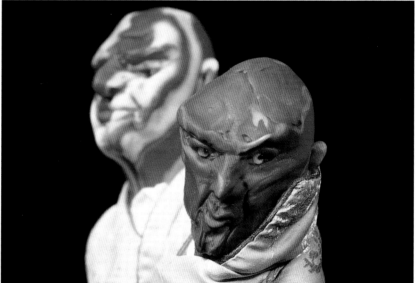

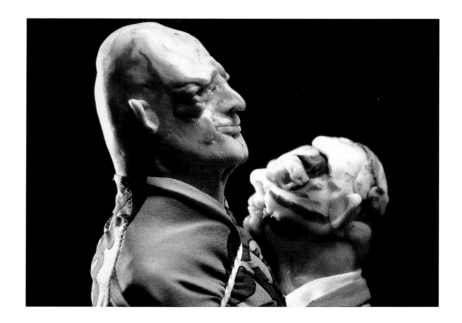

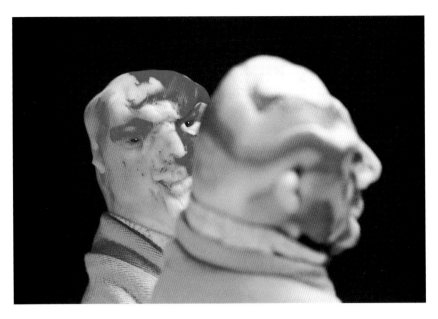

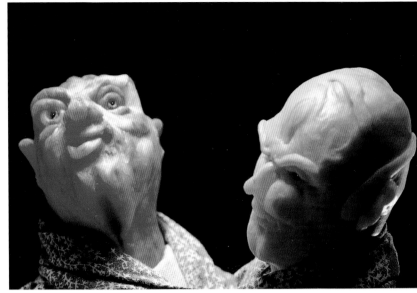

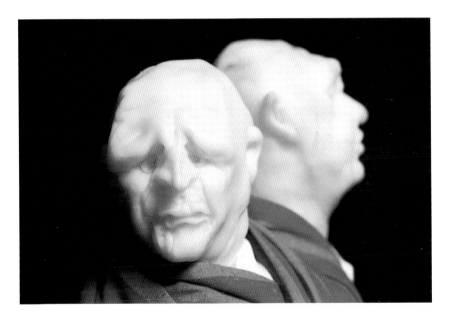

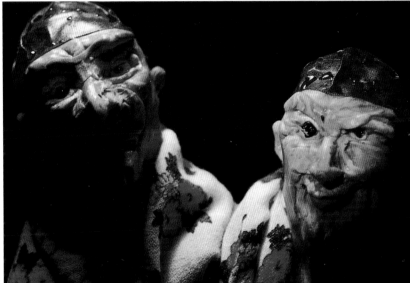

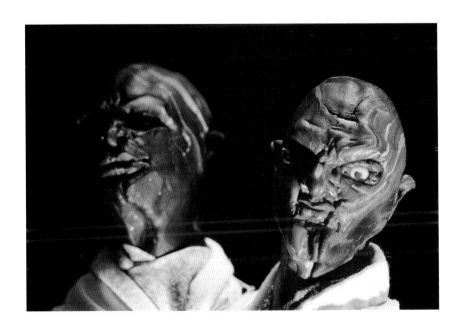

United Enemies, A Play in Ten
Scenes
1993
10 offset lithographs
69 × 99 cm each

Interview

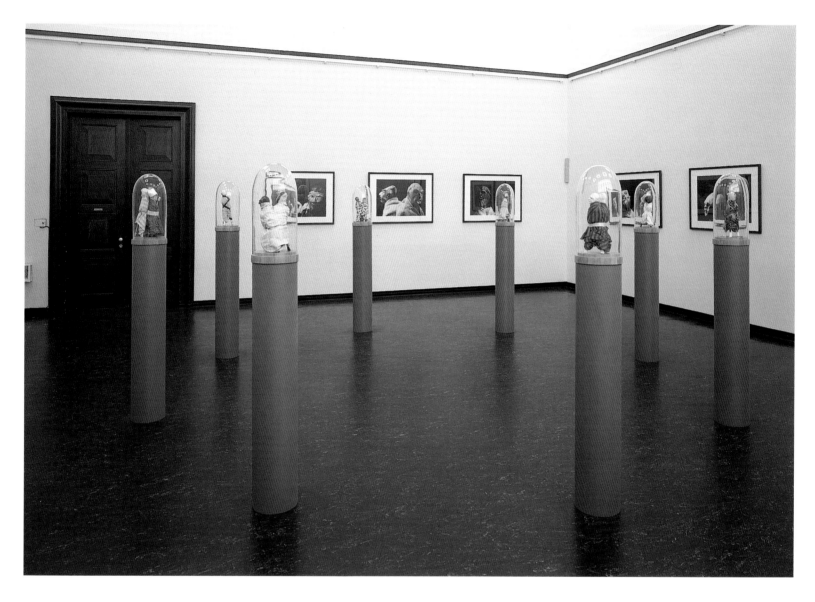

Lingwood You called *United Enemies* (1993) 'a play in ten scenes'. These were
photographs which could have come from the staging of some characters
in a violent puppet show or pantomime. The figures seem quite cruel.

Schütte **I did not find them cruel, I just found them funny. The photographs
helped the figures a lot – without the large images behind, I think the sculp-
tures would not have been seen. Later on somebody told me they were about
the German unification but I couldn't really follow that.**

Lingwood But you had developed an interest in physiognomy, in ideas
of deforming or defacing – like caricature.

Schütte **After 1992, after making *Die Fremden* in Kassel, I had a grant to stay
in Rome and I started looking at the great classical sculpture. I didn't look
whilst I was making *Die Fremden* because it would have been a distraction. If
you don't know what to do, history is really a dangerous field to go digging
around in. But when you do have an idea, then it's very useful – to
get information or to revise your work, or to revitalize you. If you look at
the hundreds of heads in the Capitoline Museum, or some of the Bernini
fountains, they are incredible. Just to look with fresh eyes, as if they were**

United Enemies
1993
foreground, fimo, fabric, wood,
glass
Figures, from 32 × 18 × 14 cm to
37.5 × 18 × 23 cm; plinth, h.25 cm;
bell jar h. 190 cm
background, 10 offset lithographs
69 × 99 cm each
Installation, Kunsthalle Hamburg

done today, not with the tunnel vision of art history.

I was there in 1992, the year there was this peaceful revolution in Italy where the heads of State and a lot of prominent people were being exposed and discredited and sent to jail. So the caricature and the satire was a reality.

Lingwood So the classical sculpture in Rome helped you, even if your own figures could hardly be said to be classical?

Schütte **For the little figures called *United Enemies*, yes. Actually the first big set of them was made in Rome.**

Lingwood The clothes they are wearing parody the folds of classical sculpture?

Schütte **They are just sticks with a head on top and another stick that builds the shoulders. I used my own clothes to wrap them in and form the body. For me they were puppets and not related to classical art.**

Lingwood The repertoire of expressions is very broad. At what point did you decide that a certain expression was right?

Schütte **I disciplined myself to modelling each head for one hour only. They have no hair, so the face is more concentrated, more general, because hair always suggests a particular period. Many Roman heads have this fantastic curly hair, but that would have limited me too much – and it's twice the work!**

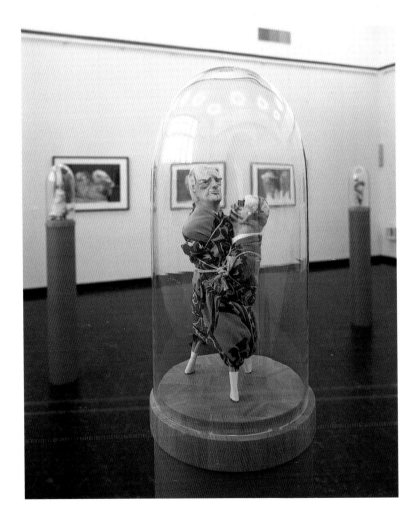

Capitoline Museum, Rome
Interior

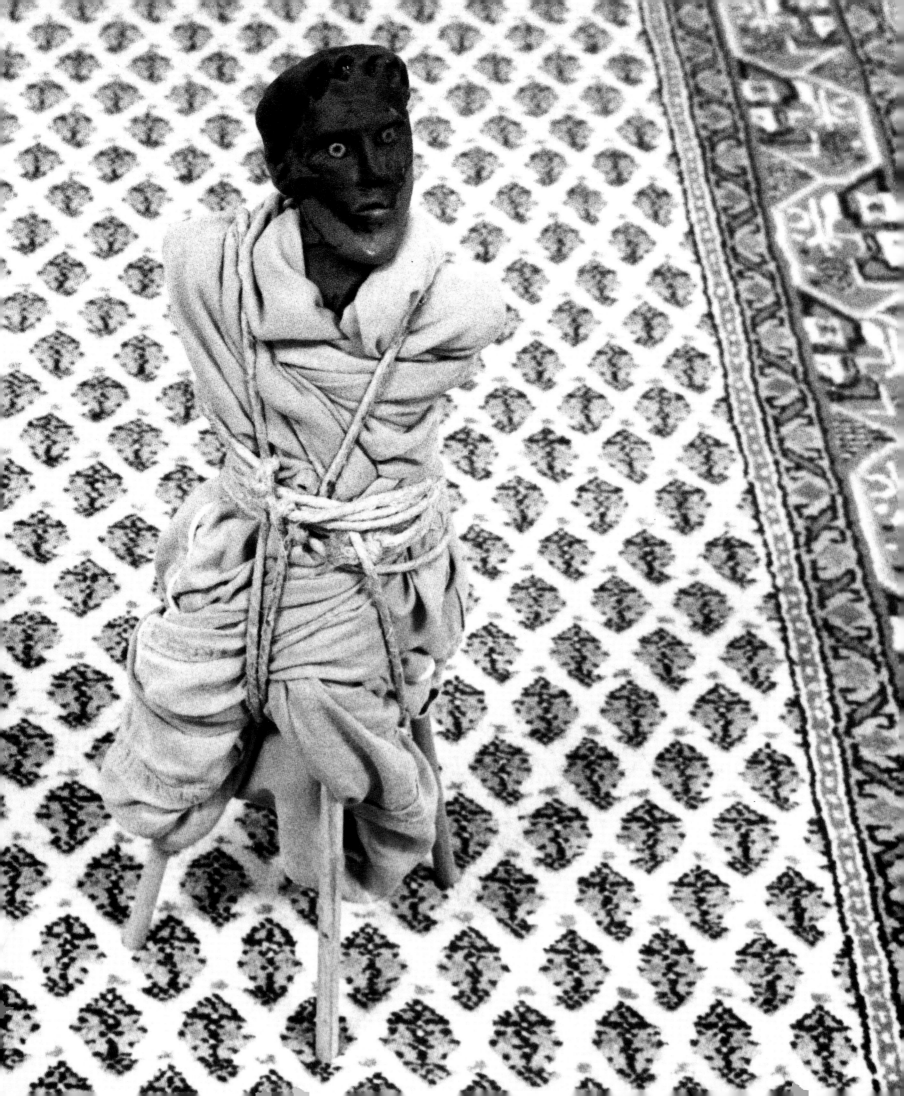

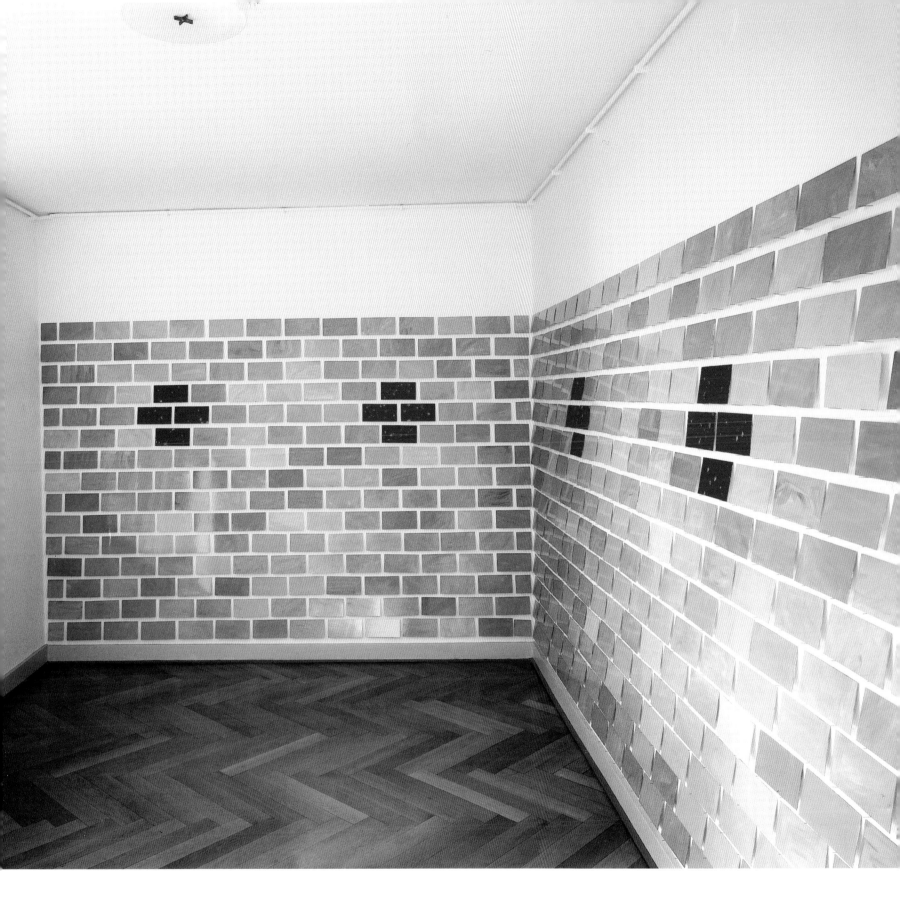

below, left, **Bühne** (Stage)
1980
Painted wood
Scale 1:20

below, right, **Kiste** (Box)
1980
Cardboard
Scale 1:20

to situations with great flexibility.

Although it is possible to detect developments in both the content and the formal/technical aspects of Schütte's career over twenty years, there is never a sense of him advancing in a linear way towards a predetermined goal. The various series of works are not lined up along a preconceived route, but form spheres of equal value that exist side by side. Early in his career Schütte spoke of creating a 'repertoire'. This term, drawn from the performing arts, refers to a readily available collection of texts, techniques and experiences, a pool that is arranged and constructed so that it can be drawn upon according to circumstance. Compared to the earlier avant-gardes, this notion seems fairly conventional. However, with this strategy Schütte

brought to their conclusion the stagnation or failure of the modernist utopias which had been omnipresent throughout his school years. A repertoire assumes that different kinds of work are represented, so that the differentiation between individual fields such as construction (the models), sculpture (the figures) and painting (the banners, paintings and watercolours) becomes of great significance. The requirements and possibilities of each specific field came to assume increasing importance for Schütte. Although his work is based on such divisions, each separate piece combines a wealth of transitions and techniques, while related themes are treated differently from one work to the next. The construction of a repertoire may follow certain conventions, but its value becomes

Modell und Ansichten (Model and
views)
1982
Wood, mixed media on paper
Dimensions variable

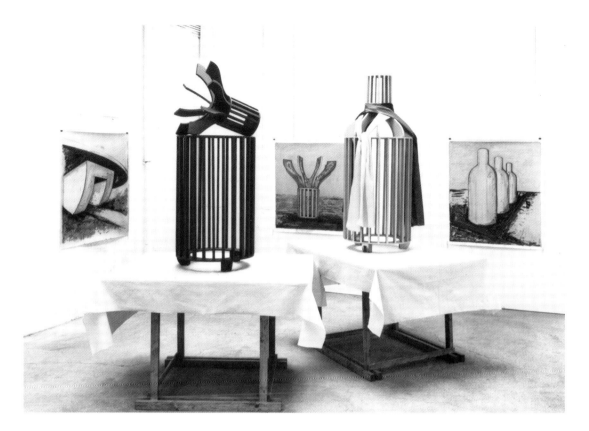

apparent when its constituent parts are put
into practice.

Construction

The basis of a series of architectural models, begun
in 1980, is a functional approach. For the group
exhibition 'Westkunst' in Cologne, which drew in
a great arc of works by many artists from the 1930s
to the present day, Schütte had wanted a large
stepped ramp with a viewing platform to be con-
structed, which was to tower over the surrounding
events like a white *Schiff* (Ship, 1980). This would
not have been so much a new work contributing
to the overall richness of the exhibition, but more
of a pragmatic offering, an ironic commentary. The
ramp would have offered the possibility of overview
and detachment, and, as a quasi-theatrical con-
struction, revealed the staging of the exhibition
itself. Looking down from above, one would have
risen to the vantage point of Gulliver, and achieved
a new view of things.

The project was never realized. In its place,
Schütte exhibited three models, hitting upon an
extremely fruitful means of representation, one
that he has pursued to the present day. This quickly
resulted in misunderstandings with regard to his
work: that this sculpture was really architecture,
that the artist wanted to play architect. Schütte
has spoken of a 'motif', a particular, pictorial frame-
work that can express a range of ideas. Nonetheless,
selecting the 'architecture' motif is not an arbitrary
decision. It points, for example, to Schütte's
early enthusiasm for 'spaces full of meaning'.
The connection with a built reality could resolve
the problem of autonomy; the poverty of actual

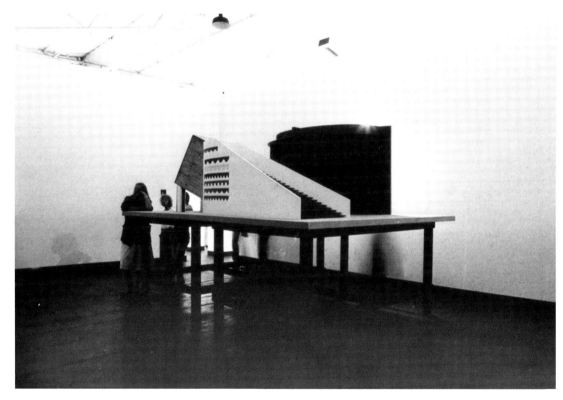

Installation, 'Westkunst',
Cologne, 1981
l. to r., **Kiste** (Box, 1980), **Bühne**
(Stage, 1980), **Schiff** (Ship,
1980)

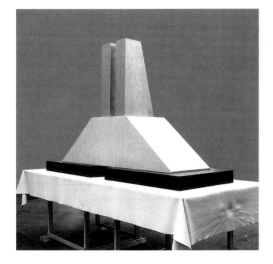

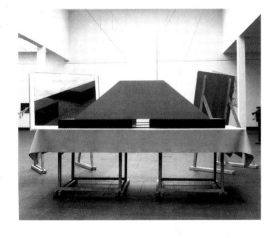

Modell für ein Museum (Model
for a museum)
1982
Wood, paint, lacquer on paper
Dimensions variable
Collection, Kunsthalle Bern

Grab (Grave)
1981
Varnish on paper
130 × 110 cm

architecture (and its postmodern incarnation) is
revealed as a contemporary backdrop; built signs
increasingly replace the faces of social agents;
and finally, the surrounding walls become an echo
chamber for the individual beyond one's own skin.

From a grammatical standpoint, a model might
be said to be in the conjunctive tense. It not only
symbolizes something not actually present, but
treats its referent (and itself) as one possibility
among several. It creates a fundamental distance
from its object. The curious thing about this
distance, however, is that it not only establishes
the possibility of analysis and critique, but also
stimulates the imagination and thus opens up a
space for ambiguity. In this sense, when talking
about Schütte's works, terms such as 'built images'
and 'the mind's images', or metaphors such as
the stage and theatre, are often appropriate. His
models maintain a link with the critical intentions
of Conceptual Art; reflection upon the context is
inscribed within their construction. At the same
time, however, his strategy goes further, incorpo-
rating new ways of shifting attention towards a
specific content beyond artistic self-reflection.
The model enables the artist to employ an evocative
form of representation without slipping into the
complacency and isolation to which the then
contemporaneous German neo-Expressionism,
finally succumbed.

The Artist's Life
It begins with the end. At the start of Schütte's
career there stands a monument to death, *Grab*
(Grave, 1981). The picture could be read as the
expression of a personal state of mind, as a
youthful fantasy, coquettish yet serious. But the
way the work is executed indicates a more universal
application. The figures provide the construction
with scale, rendering it monstrously large; it
becomes a crude hybrid, a cross between a grave-
stone and a building. He has hardly begun, yet
Schütte provides us with a summary of the things
that could eventually happen to him: being reduced
to a name and a biography, trapped by history,
poured into the mould of abstract fame. In this
scenario, the work disappears behind the social
claims placed upon it. This is not presumption on
the artist's part, but a realistic assessment of the
conditions in which an artist works: this is how it
can happen. Accusation? Resignation? This model
of this 'stupid box' leaves the question open.

Thus begins a dense sequence of works in the
early 1980s, thematizing what one might call 'an
artist's life in the late modern age'. From various
points of view, the work tells of the conditions of
artistic production and its self-understanding. This
is effected through models and sketches as open in
their narrative and metaphoric content as they are
in their form. The *Modell für ein Museum* (Model for
a museum), conceived in 1981 and realized in detail
in 1982, is similarly an image of finality like *Grab*
(Grave, 1981), but it goes beyond it in harshness
and sarcasm. In a provisional yet skillful way, it
presents itself as the newest contribution to the
museum boom. The external form of the building,
however, has a chilly strictness and authority. The
'revolutionary architecture' of the period around
1800, with its utopian perspectives and eloquent
forms, is clearly an influence, as is Minimal Art –
not to mention a child's building blocks. It stands

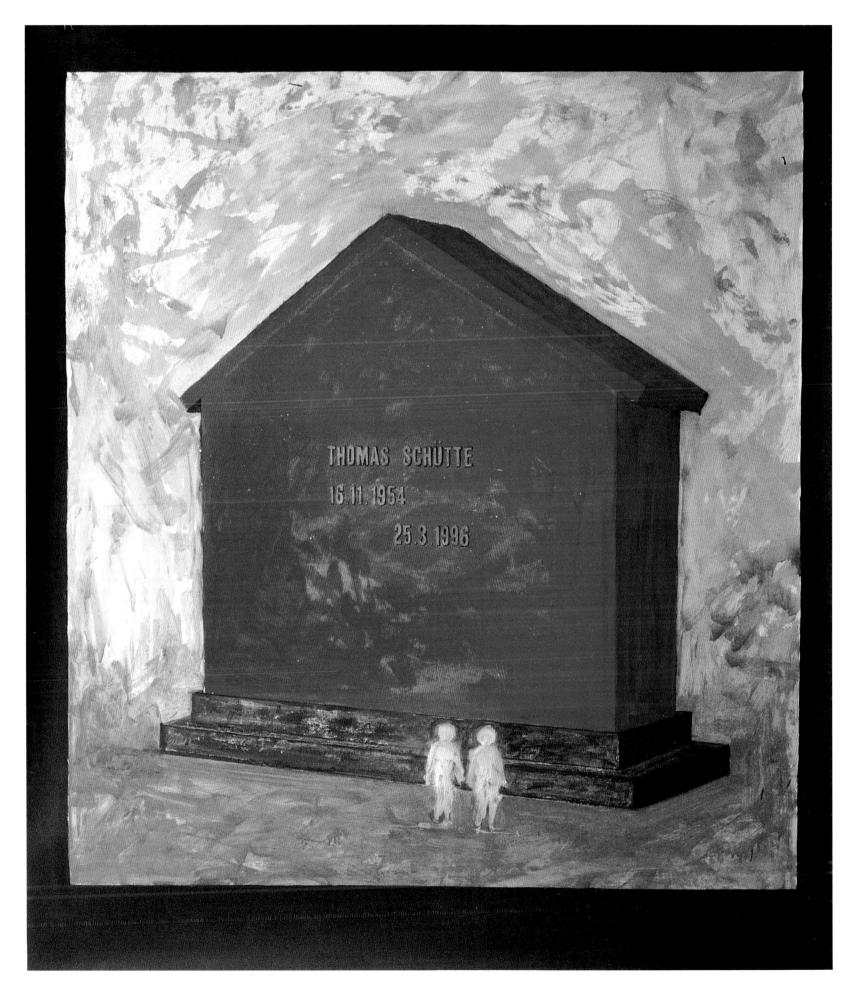

These theatre pictures appear only occasionally, as in the three works in the exhibition 'Westkunst', in which the *Bühne* (Stage, 1980) remains empty. The backdrop effect of many of these models, however, is obvious (for example, in *Joker-Poker*, 1984, or *Für K. [Hamburg]*, 1985). They have a distinct display front; the rest is a support construction – although equally important – reduced to the barest essentials. But in a more general sense as framing metaphors, the ideas of theatre, the stage and performance underlie particularly those works that draw a sinister or nightmarish picture. Thus, for example *Sicherheit* (Safety, 1981) seems to offer a threat. Its schematic silhouette is halfway between military architecture and a cooking pot, a barely credible Bogeyman, its power to frighten undermined by its golden inscription. Trust and intimidation blur into one.

This potential for contradiction is given free reign in the *Pläne I-XXX*. Beginning with the explosion of a nuclear bomb, the course leads via missiles, bunkers and mass graves to the monuments of an architecture of power, but also to such commonplaces as a motorway junction, a satellite town and a family home. Using large stencils, the pictures have been casually sprayed in black on yellow oilcloth. Their identification, in red, as a plan suggests that they are merely an indication of future possibilities, implying the perverse logic of a prescriptive design. The contemporary context is that of an increasingly conservative society; a renewed dominance of 'practical constraints' after a decade of attempted change; and the debates about the deployment of new NATO missiles in Germany. *Pläne I-XXX* are, however, not a credulous

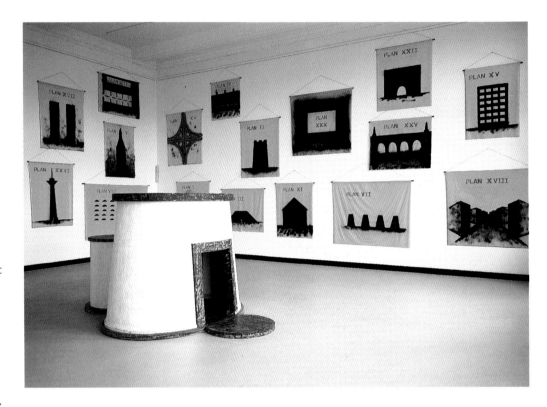

evocation of looming catastrophe in the sense of propaganda. As the final Plan makes clear, this is a theatre of images, one which shows fear as an inevitable given, the truth of which must be examined elsewhere.

Other works extend and vary these themes, with images ranging broadly from irony to despair. The vocabulary is supplied by architectural inventions, which can be prompted by real buildings as well as decontextualized objects. In *Hauptstadt II* (Capital II, 1981/84) they are monuments that seem to stand, slogan-like, for social themes such as power, consumption, success. The cool nonchalance with which these 'definitive' architectural

background, **Pläne I-XXX** (Plans I-XXX, 1981); *foreground,* **Modell für Eis** (Model for Ice Cream, 1987)
Spraypaint on oilcloth
Dimensions variable
Installation, Kunsthalle, Hamburg

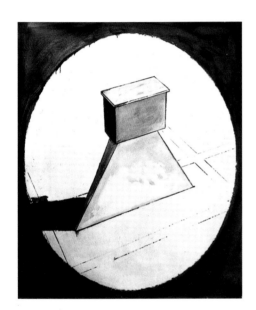

above, **Hauptstadt II** (Capital II)
1981/84
Wood, paint
8 units, 550 × 140 × 70 cm each
Installation, 'von hier aus',
Messegelande, Halle 13,
Düsseldorf
Collection, Kunsthalle Hamburg

opposite, **Hauptstadt II**
(Capital II)
1981
Paint on paper
130 × 110 cm each

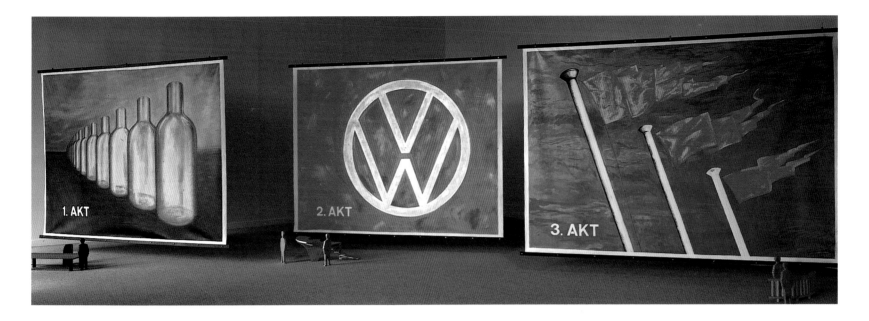

Dreiakter (Three acts)
1982
Oil on linen
1000 × 250 × 200 cm each
Installation, Centre Georges
Pompidou, Paris
Collection, Centre Georges
Pompidou, Paris

ideas are outlined subtly intensifies the impact of the vision. But for Schütte during this time, the negative fantasy of the designs also contained within it 'the risk of losing sight of reality'.[7] When individual motifs from *Hauptstadt II* later turn up in the theatre backdrops *Dreiakter* (Three acts, 1982) or *Pentagon* (1986), they convey, in a manner less dramatic yet all the more complex, a sense of the socio-political status quo, all-encompassing yet fragile and presented by Schütte for our unbounded admiration. As early as 1981, the revamped and somewhat grotesque creation *Kiste* (Box) combines banality with ostentation and scornful confidence. Even a really quite dark image such as the *Bunker* is transformed into something apparently positive in its blue version (1984), which presents itself as an attractive utopian model set against a radiant depiction of springtime. Still later, in *Blue Box* (1986) or *Controllo* (1988), the images of power and surveillance are shown in deliberately 'friendly' colours. Whereas the unreality of the earlier works led to the realm of the inconceivable, these models employ a tactic that evokes the same themes in an entirely comprehensible, even agreeable way. With this affirmative gesture, art is catching up with reality, the face of which has been wearing a

smiling mask for quite some time.

In a very precise sense, however, the unreal reappears in the context of a theme of fundamental historical importance for Schütte's generation. *With No Words* (1981/87), a work which has received less attention than others, ventures to suggest a monument to victims and perpetrators with no named historical reference. *Wo ist Hitlers Grab?* (Where is Hitler's grave?, 1991) allows no doubt as to its subject matter, and could only have been conceived by a German artist. The work was produced in reaction to the violent outbreaks of neo-Nazi xenophobia in Germany after re-unification. It deliberately makes a doomed attempt to convey the horror and suffering of World War II purely by quantifying the unimaginable number of the dead. The pointless, scandalous and desperate recalculation of the bald numbers is carried out on sheets of paper hung on the wall behind the tables of the installation itself. The notes consist of stamped texts, as if both to neutralize and monumentalize the repellent nature of these calculations. They could be rough drafts for those bronze or stone plaques usually found at memorials, except that here, both emotional appeal and rational didacticism are undermined from the very beginning.

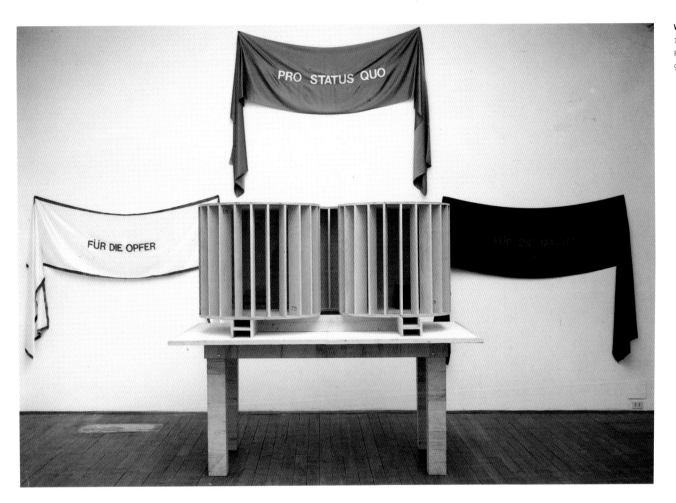

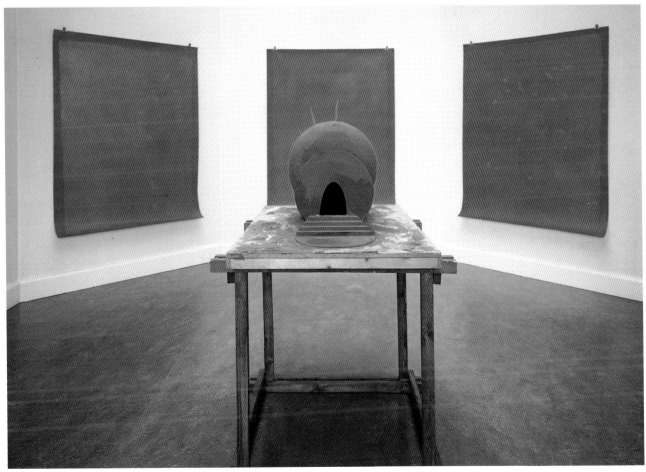

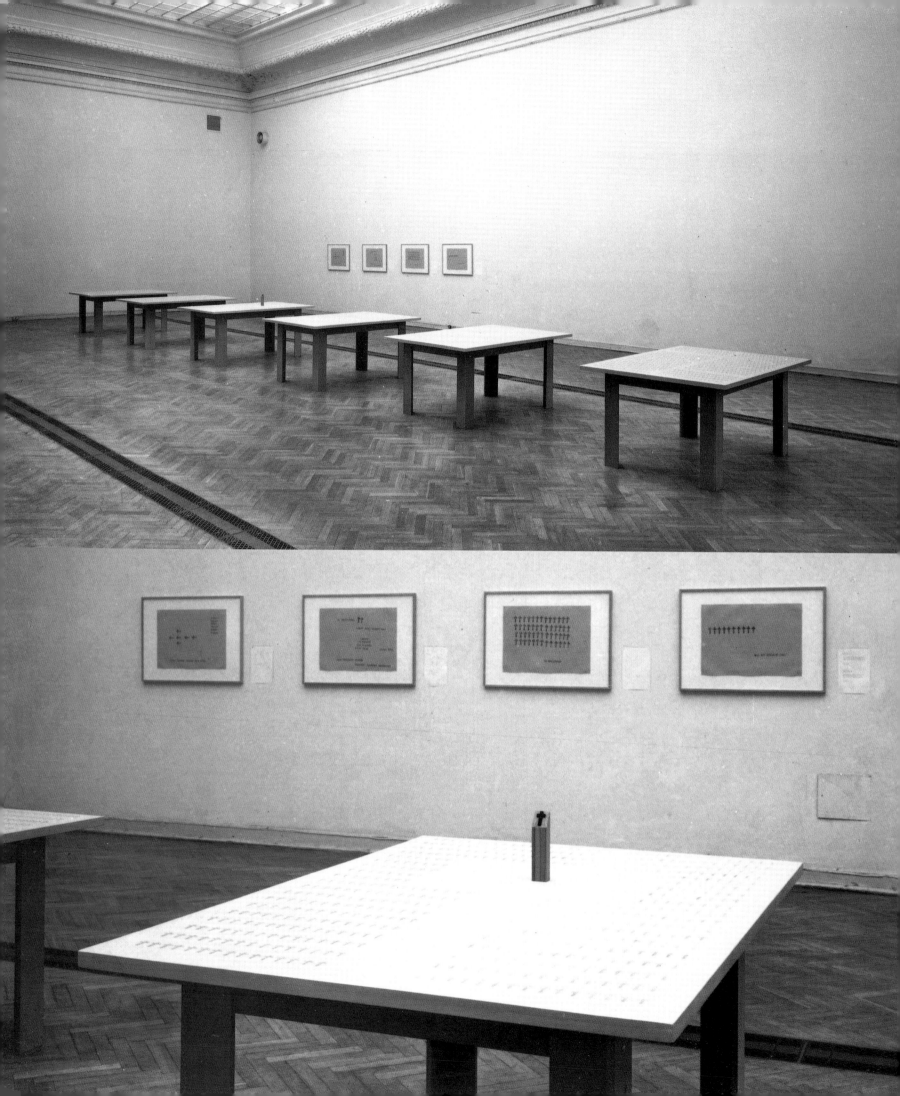

Neither the assertion of the absolute figure of fifty-two million dead, nor the calculation that in every hour of World War II an average of 1,000 people died violent deaths, can bridge the gulf between knowledge of the facts and the impossibility of really understanding them. The transition to another dimension doesn't help either; on the contrary, the spatial picture also frustrates our desire to understand. It would take not merely six tables, as in this installation, but about 1,000, to commemorate each individual fatality with a stamped cross on the table tops. So the unimaginable is neither suppressed in the work nor evoked by dramatic rituals – it is preserved as it is. Only the idea of sealing each individual death by stamping it, acknowledging it as irreversible and lasting, may suggest a solution between the unimaginable and our own lives. In this case, however, the deaths of the perpetrators would have to be similarly sealed. In the context of the title, the one stele on the 'burial ground' of the tables seems to indicate something like a possible monument to the perpetrator. A scandalous suggestion, but one which refers to the real scandal: that the perpetrators are like the undead, never properly buried and therefore still at large, still able to be called to arms. These questions seem possible only as artistic speculation, under the conditions of the model and behind the shield of a desperate absurdity, even if they test the capacity of the construction to its limits.

1:1

When, having made the negative and menacing models, Schütte spoke of wishing to return 'to the original concept of positive suggestions',[8] he might also have been referring to those grounded in the scale of reality itself. Since the *Schiff*, the model had been more than an opportunity to formulate vivid images through playful detachment, miniaturization and enlargement. The hypothetical nature of the model is essentially more fundamental, and is not limited to particular proportions. As well as the standard proportions of 1:20 or 1:5, one other option is lifesize. We might assume that this scale might carry out certain functions in a real environment, but it is no guarantee of greater reliability.

Opportunities to examine the 1:1 scale in specific terms do not appear until the mid to late 1980s. The *Schutzraum* (Shelter) erected for Sonsbeek in a park in Arnhem in 1986, which was briefly used to exhibit art, seems to be the cryptic obverse of the rather cheerful atmosphere of the event. The technological shape of the concrete cylinder, the locked steel door and the ominous blue sign at the entrance might lead one to suspect for a moment that this was a genuine relic from World War II, to which the city's name is linked by a well-known battle. This (inner) image, however, is rapidly replaced by the sense of a backdrop. The sculpture cleverly deploys the effect of follies, architectural set pieces, familiar from the history of garden architecture. Like the *Tor* (Gate, 1986) in the Jenisch Park in Hamburg, the work acknowledges the organic structures of the park, while displaying a new interest in representational and functional integration with the outside space. The work's character as a model is preserved not only in its material qualities, but also through a certain

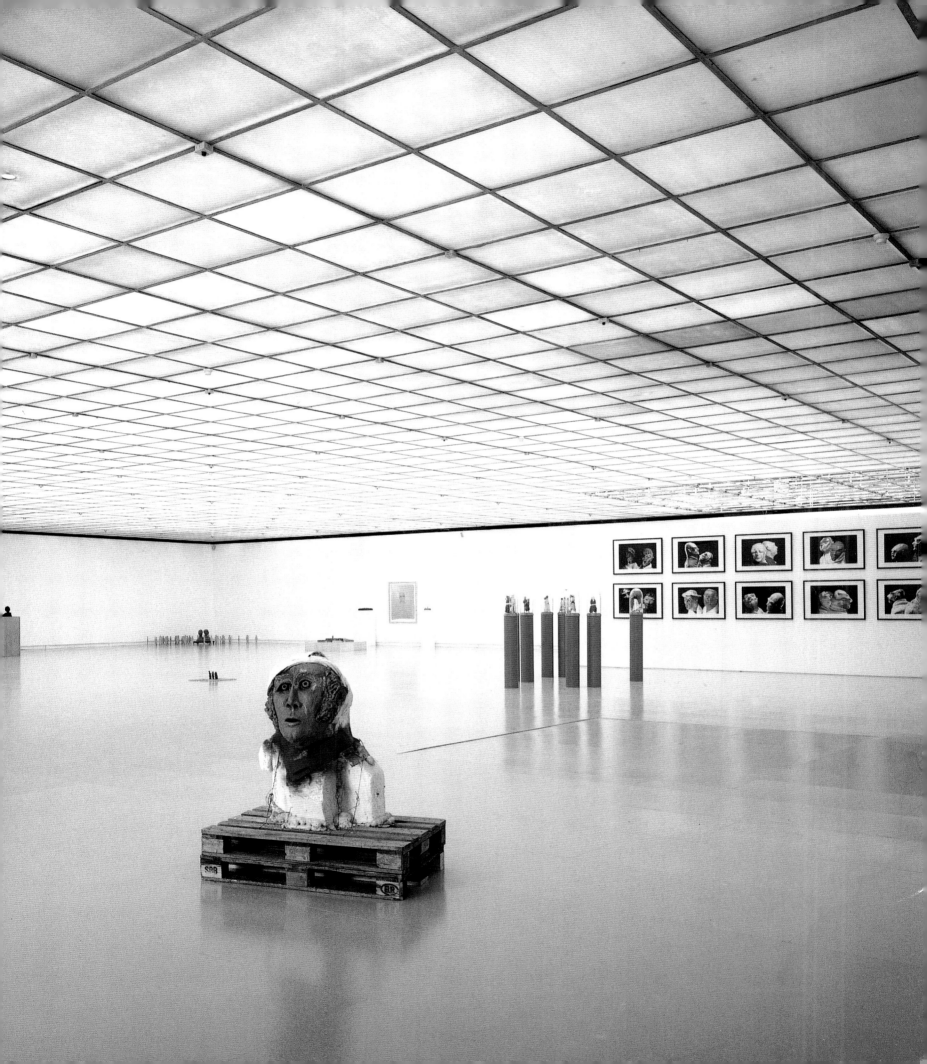

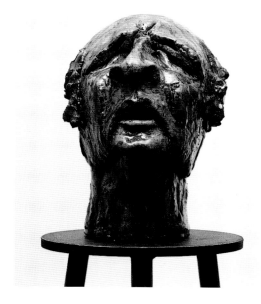

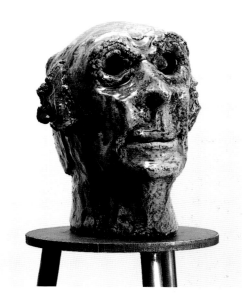

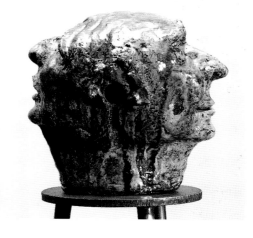

Vorher-Nachher (Before-After)
1993
Glazed ceramic
20 × 30 × 30 cm

a decidedly modernistic method which could only be described as bricolage. The work is developed to the point where the central question or the core of the intention becomes apparent and goes no further. The means employed must serve only this intention, and can be as provisional and 'rough' as needs be. From this point Schütte advances a step further. The parts of the work that are incomplete and badly made contribute to the expression for which he is striving. The roughly carved polystyrene blocks, the protruding mounting-foam, the restraining wires and not least the transport pallets used as plinths in *Alain Colas* have an inappropriate/appropriate connection with the modelled clay head. The face, marked by exhaustion and astonishment, of the lone yachtsman who vanished in the Atlantic, and for whose monument this is a design, only begins in the interplay of these elements to speak of the sailor's heroically senseless fate. There is no hierarchy among the heterogeneous parts of the figure, but there is a precarious balance – it might be described as an accidental situation. The same might be said of the relief of the *Weinende Frau*. In this design for a fountain, it is the apparent irreconcilability between the self-absorbed face and the dirty and brutal treatment of the surface, including the flowing wax tears, that makes the emotional disintegration and absorption of the character plausible. The process is reminiscent of earlier works such as *Modell für ein Museum* and *Pläne I-XXX*: it is a path of exaggeration, whose purpose, however, is not the ironic treatment but the clarification of its object.

At the same time Schütte pursues one other possibility, which lies in the realm of the miniature. These are the heads, a few centimetres across, which, draped with bits of fabric, become three-legged puppets – strange hybrids of a theatrical world, half makeshift construction, half major performance. At first they too were a kind of relaxation exercise. The material is a plasticine-like substance for children and hobbyists, which can be easily worked. The heads are handmade in the truest sense of the word. As with the watercolours, a few effective skills can be acquired relatively quickly. These puppets have already appeared individually in connection with larger works (*Ohne Titel* [Untitled, 1985]; *Bank*, 1985-86; *Mohr's Life*, 1988) compared to the scale figures they enhance individuality and thus the sophistication of the picture as a whole. *Teppichmann* (Carpet man, 1988), an emblem for the ambivalences and absurdities of the artist's life, exhibits one of these figures in a stage portrait. The whole potential of the little faces is only emphasized, however, when Schütte changes scale again and, in the early 1990s, has such heads pose as models for large-format photographs and prints. Now it becomes even more apparent that with these heads the approach towards the diversity of figurative sculpture takes the form of detailed, exaggerated physiognomies, even the distortion of the caricature. The extreme close-up of the photographs and the theatrical lighting sometimes border on the grotesque. One must go back to the eighteenth and nineteenth centuries (from Franz Xaver Messerschmidt to Honoré Daumier) to encounter similar solutions in the search of a contemporary representation of people beyond a now obsolete

classicism. In the sculptures and prints of the *United Enemies* (1993-94), for example, constellations between the sublime and the ridiculous, between tragedy and comedy, which could be taken from a Shakespearean performance, are put into play. The sculptures and their photographic counterparts, however, go beyond the caricature and the grotesque. They emerged in the context of a lengthy stay in Rome. This entailed not only an intensive immersion in the classical tradition of figurative art, but the experience of a contemporary theatre of power, arrogance, corruption and stagnation, with a script based on the Italian social and political crisis of the day. Even if the works return such real events into the universal, titles such as *Alte Freunde* (Old friends, 1992-93)

or *Innocenti* (The Innocents, 1994) are self-explanatory. We are presented with barely likable types and characters who, themselves powerful, seem to be moulded by larger powers. The ambivalence of the expression of these 'legal criminals'[18] is the same found in any moral consideration.

The small and large clay heads of 1992 and 1993 transfer Schütte's achievements to a traditional material and a larger scale. The brutality and provisional nature of *Alain Colas* are reduced, the physiognomy is more differentiated, the modelling more skillful. Although a sculpture such as *Janus Kopf* (Janus Head, 1993) shows an almost classical conception of nature, dignity and monumentality, it does not grow out of academic adaptation but

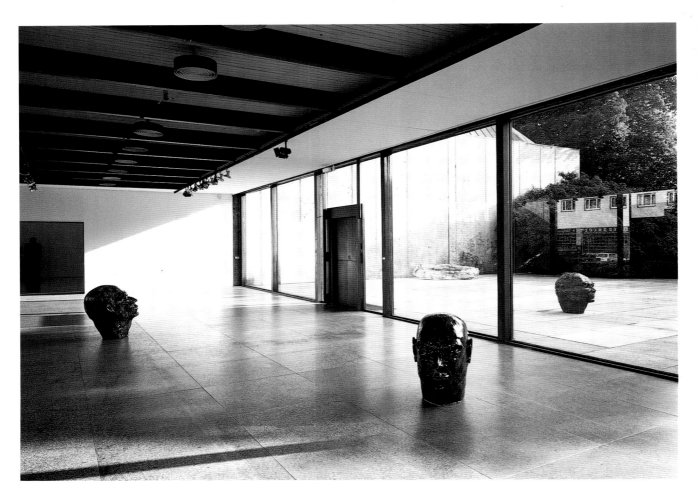

Große Köpfe (Large heads)
1993
Glazed ceramic
h. approx. 100 cm
Installation, Württembergischer
Kunstverein, Stuttgart, 1994

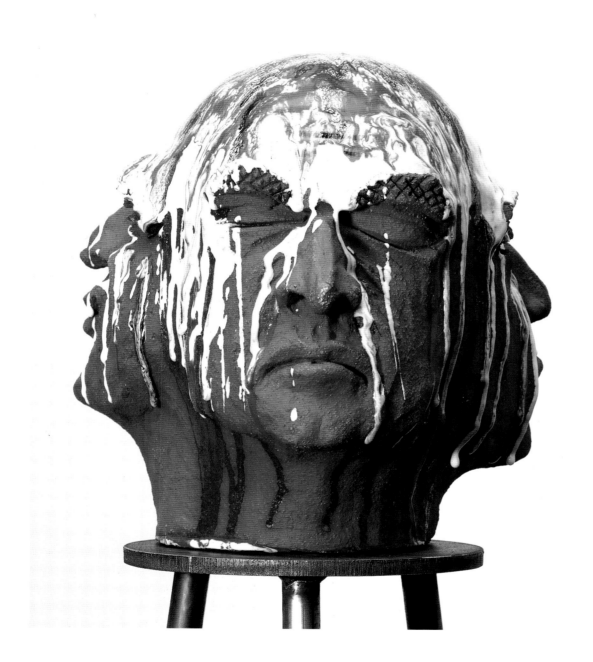

rather exploits the infringement of rules, pragmatism and chance. The 'accidental' glaze contributes considerably to the tragically composed expression of the faces. The anatomically delicate problem of connecting the two heads is overcome in a surprising way. A circular hole passes diagonally through the sculpture through which the iron bar on which the heavy clay head is carried is inserted. The hole becomes the shared ear of the mythical construction of the Janus head. At the same time it pierces through and opens this two-fold personality, which, all-seeing and self-absorbed, exists in the past and the future. This pragmatic *coup* solves an artistic problem and creates an effective but uncertain symbiosis out of continuity and fracture, totality and fragment. Ultimately it is a matter of giving figurative sculpture a credibility that prevents it from being mere quotation, and identifies it as a possibility for the present. In the end, the ambiguous monumentality of the head also contributes to this. Without a proper context, it acts as the relic of a large statue, a monument whose purpose has been forgotten: when the work was first exhibited, Schütte had placed two sceptical and astonished little figures next to it.

These pieces were preceded by an intensive period of work with clay sculpture, the result of which was the group of figures called *Die Fremden* (The Strangers, 1992). It differs in many respects from the other sculptures, and, as a complex group, represents a new approach despite some overlaps. It is the first figurative work for an outdoor space, and the first time that the whole body becomes a work of sculpture in the narrower sense. The paint is applied not in a summary or anarchic way, but

Untitled
1993
Glazed ceramic
h. approx. 30 cm

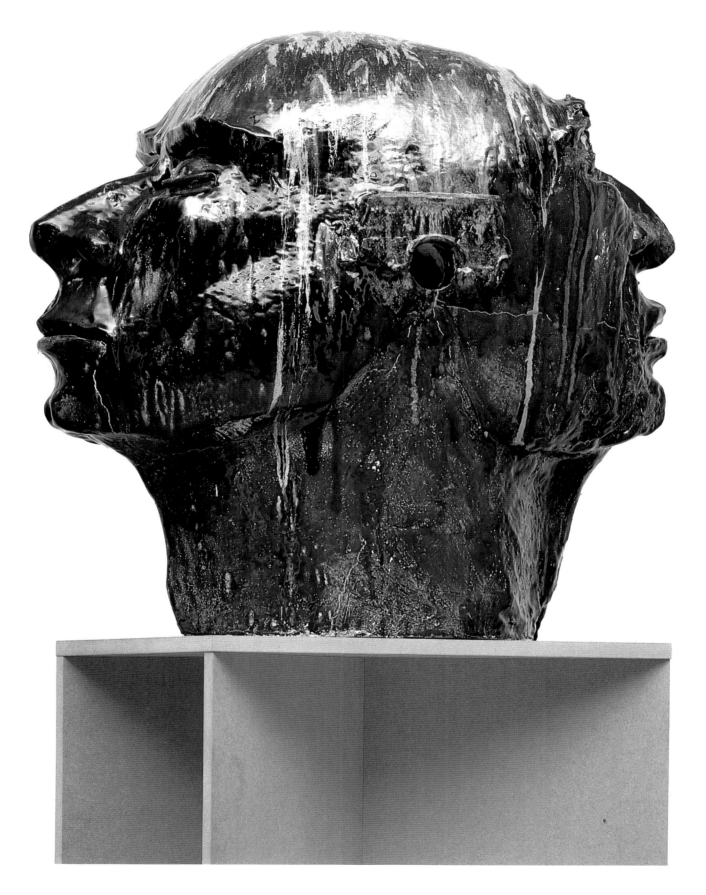

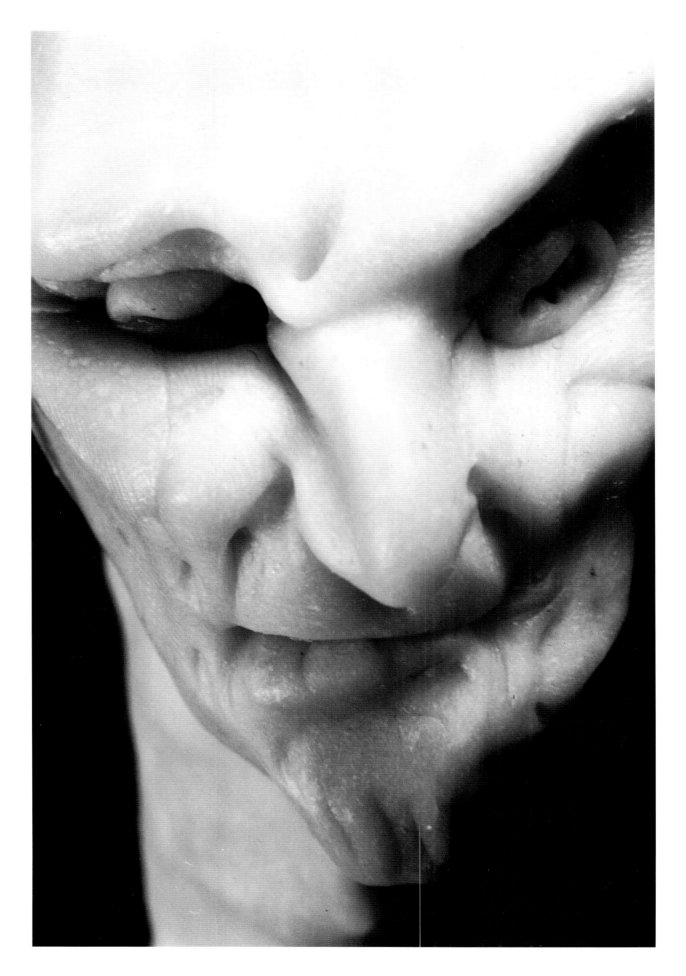

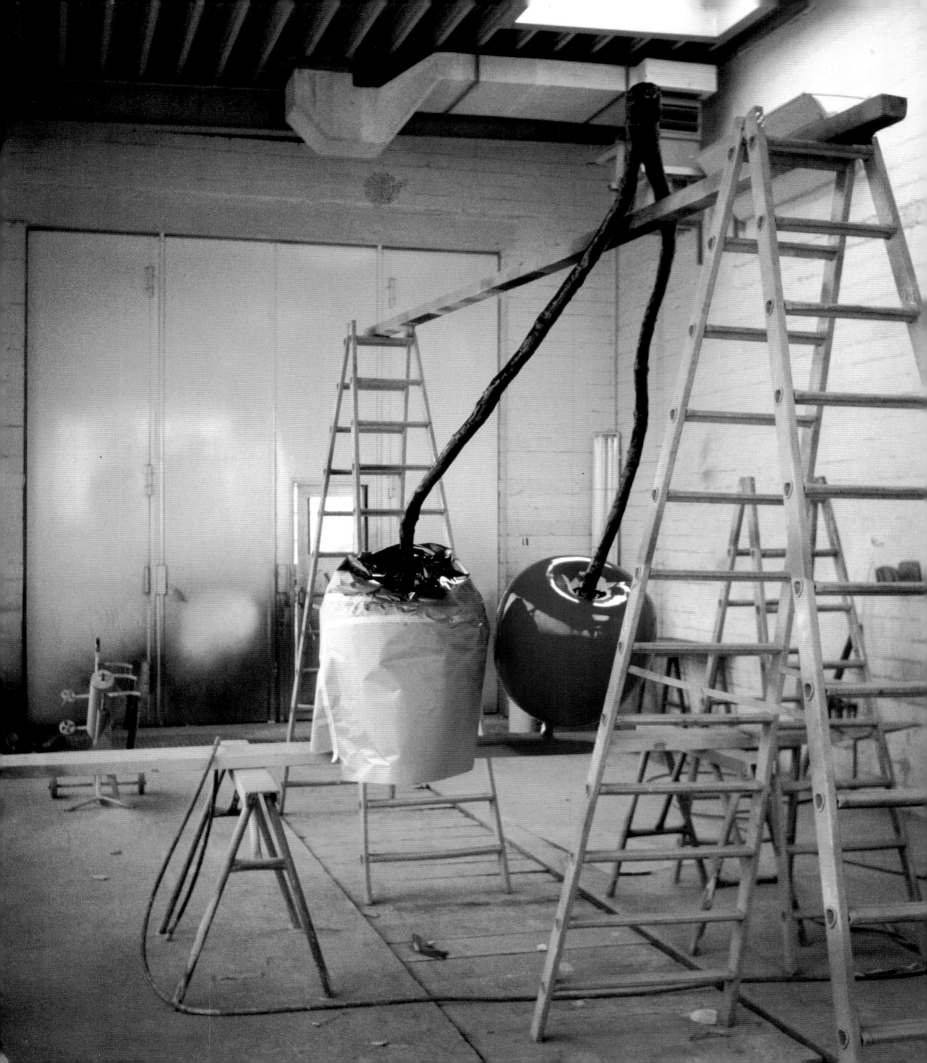

Contents

When Thomas Schütte addressed the theme of a utopia he did so using small maquettes which suggest de Chirico's spaces, hallucinatory and impossible. When Fe chose to celebrate a hero, the sailor Alain Colas, he set the tragic ceramic head on two prosaic supports; while with *Die Fremden* (The Strangers, 1992) at Documenta IX he celebrated an ordinary image of lost humanity. It comes as no surprise then that, when he was invited by Kaspar König to the Skulptur Projekte Münster in 1987, an exhibition of works commissioned for public spaces around the city, Schütte decided to create an anti-monument and ended up by celebrating two cherries. To quote the artist, 'Many of my works have to do with power and are intended as parodies.'[1]

An open-air sculpture, conceived for its original site in the Münster Harsewinkelplatz, *Kirschensäule* (Cherry Column) is a rather stout, four metre-high column made of the local sandstone – a material which can be found in most historical buildings of the city, particularly the major landmarks of the castle, the town hall, the cathedral and the market. The column is set on a slightly raised pavement that both creates a kind of barrier around the work and is also the connecting point between it and the buildings forming the rest of the square.

The top of the column is occupied by two large, twin cherries, in bright red enamelled aluminium. In visual terms the proportions between the base and the object lean

Kirschensäule (Cherry Column)
1987
Watercolour on paper
30 × 24 cm

Kirschensäule (Cherry Column),
model
1987
Wood
h. 120 cm

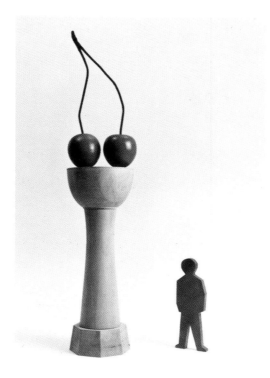

decisively in favour of the latter. Almost twice the height of its base, the hemispherical capital outweighs the column it sits on, occupying over half the full height of the work. Its slightly concave shape along with the disproportion of the whole piece with regard to classical canons reminds us, as others have remarked,[2] of a chess piece, either the castle or the queen. Indeed, a chess set simulates a battle but celebrates only its logical and playful side, while exorcizing the harder, human costs of the struggle. At first sight, the work seems a cross between a child's toy and some erotic totem, prompting a strong reaction of pleasure. The artist seems to want to offer us a dose of amusement and a serving of simple but tasty food.

The cherry is a frivolous fruit. Lucullus imported it to Rome from Pontus, a region in Asia Minor, simply because he enjoyed the taste so much. It is hardly nutritious but, to

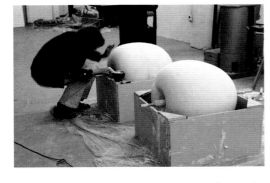

Kirschensäule (Cherry Column), in progress 1987

compensate, it is very decorative. Even as adults, eating cherries feels playful – 'Life is just a bowl of cherries' we say. We also say 'lips like cherries', which is clearly a more erotic reference. It can be no accident that Schütte chose to put two, rather than one, at the top of the base: like two lips, or two testicles. Above all, two cherries are indispensable for a pair of earrings or to start off a red bead necklace.

The column-shape, in turn, is also immensely rich in history. It was created to bear weight and, given its proportions (akin to the human body itself, with limbs hanging at its side) always embodies the sense of a caryatid, a person, a silent hero who, with apparent ease and infinite patience, sustains the weight of stone and of time. The history of Western architecture, from the Egyptian temples of Luxor to Le Corbusier's pilotis, is in essence the history of the column. All the great civilizations have celebrated their own worth by using the column as a symbol of power: Athens, Rome, the Church and its power here on earth, imperial London, Washington, and twentieth-century capitals of every political complexion.

Setting two cherries on top of a column represents the joining of two opposites: it signifies both respecting and denying a tradition[3]; combining the everyday and the perishable with the weight given to great, heroic buildings and statues. This oxymoron was repeated in the very positioning of the *Kirschensäule*, which is of fundamental significance in a show based on the concept of site-specificity,[4] and forms a sort of union between opposite terms.

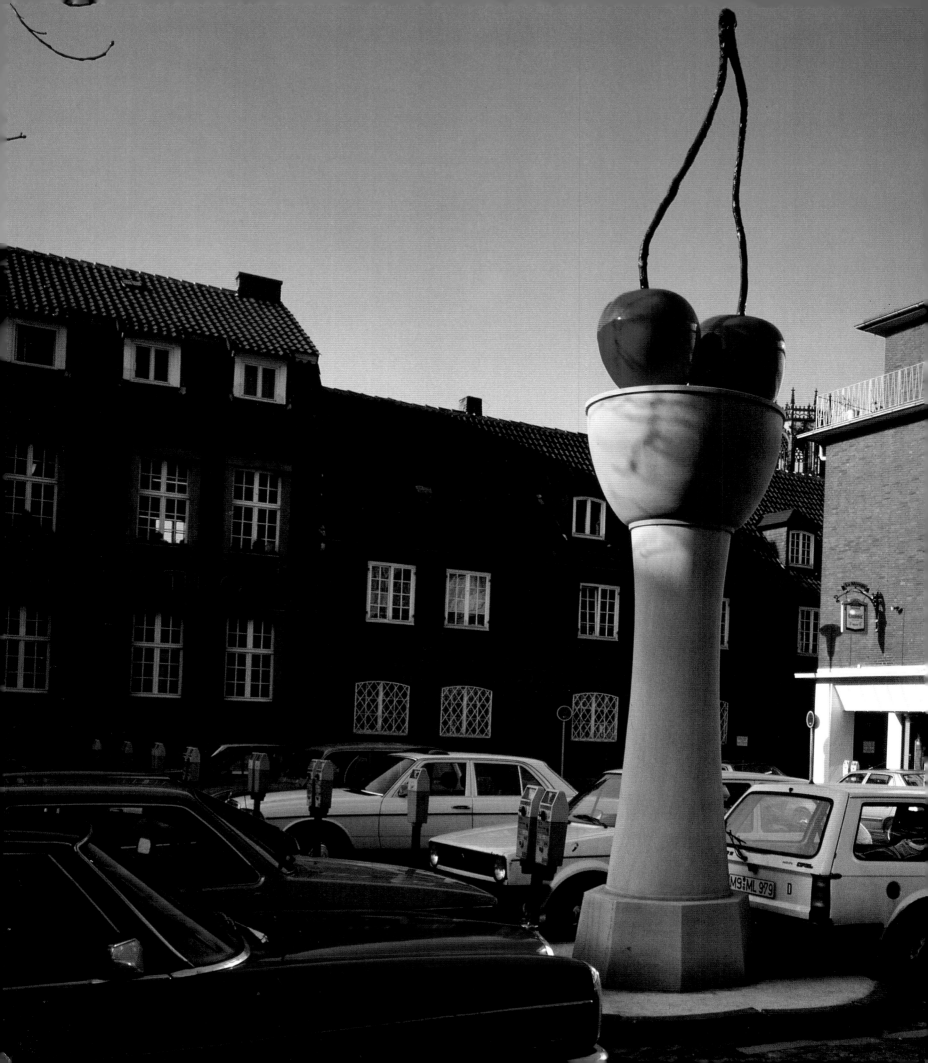

Kirschensäule (Cherry Column)
1987
Painted cast aluminium,
sandstone
h. approx. 6m
Skulptur Projekte Münster, 1987

The sculpture was placed in a sort of *piazza*, the canonical site for a monument. Münster is a medieval city that during the Reformation achieved a glorious political and religious independence through an egalitarian, anarchic struggle that was later tragically suppressed. The city today is like a well-restored jewel, with its frame of green parks and little lakes, one of many places where the arrogance of power is both glorified and hushed over.

But here, the present predominates over the past. The square that Schütte chose to place his work is certainly not among the most monumental, and it demonstrates in its architecture a co-existence of the old and the new. The whole urban centre of Münster has had to yield to today's needs: the square has now become a car-park, and the sculpture looks embedded in and suffocated by the cars. On the other hand, the artist seems to have paid homage to the car itself, choosing a material for his cherries which somehow is akin to the sleek body of a new automobile.

For this reason it seems altogether consistent that the base of the column takes the shape of a giant mechanical nut holding down a great bolt; likewise, the capital resembles a sort of bowl. It's as if the cars down below and the cherries above have contaminated the original form of the column – which in an early drawing from 1984, seems relatively ordinary but which, in a later drawing from 1996, looks as if it's already being deformed into the capital, though as yet, without the bottom 'bolt'.[5]

One of the most apparent differences between this and Pop Art – for instance the sculpture of Claes Oldenburg – is that Schütte is not glorifying a consumer object dating from a specific era. Fruit is not a product of our times but, in fact is the oldest of all food

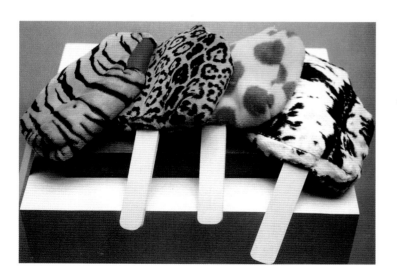

sources. In Schütte's studies for the work – large, somewhat expressionistic paintings on paper – he has depicted, among other things, a cauliflower resting on a classical capital. Also featured are potatoes, which have a long, humble history, or other more absurd fruits like watermelons, great big beachballs that swell from the earth, or the exotic and luxurious pineapple.

opposite, clockwise from top left,
Blumenkohl (Cauliflower)
1986
Lacquer on paper
130 × 110 cm

Kartoffeln (Potatoes)
1986
Lacquer on paper
130 × 110 cm

Kirschenpaar (Cherry pair)
1986
Lacquer on paper
130 × 110 cm

Ananas (Pineapple)
1986
Lacquer on paper
130 × 110 cm

Claes Oldenburg
Soft Fur Good Humors
1963
Fake fur filled with kapok, wood
4 units, 48 × 24 × 5 cm each

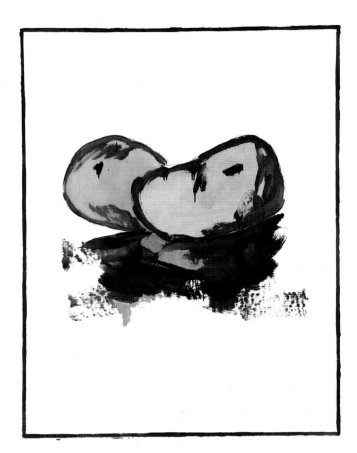

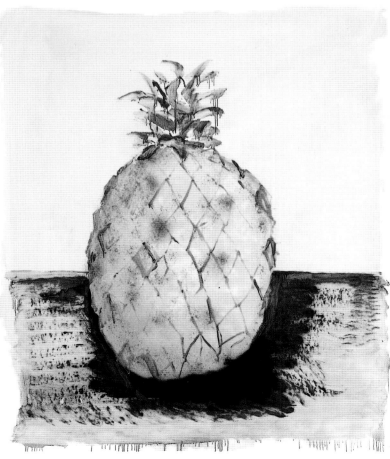